KU-534-521

DANGER!
Women
Artists
at Work

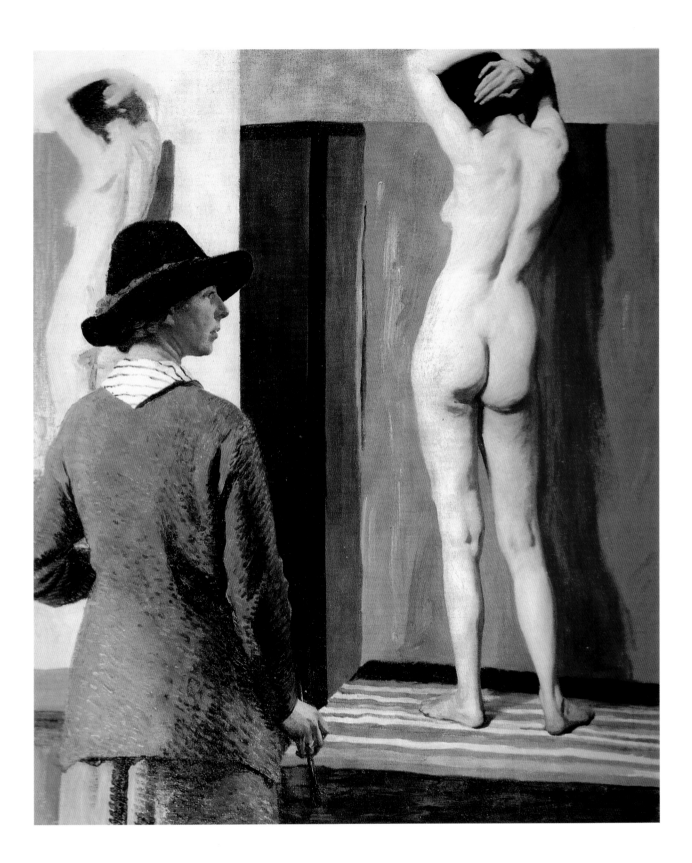

DANGER! Women Artists at Work

Debra N. Mancoff

MERRELL
LONDON · NEW YORK

Contents

Introduction

After attending a lecture at the Royal Academy of Arts in London, a young painter named Anna Mary Howitt (1824–1884) dashed off a passionate letter to her friend Barbara Bodichon. It was not the lecture that had stirred her; indeed, she barely mentions it in her letter. Rather, what had moved her to the point of feeling 'quite *angry* at being a woman' was the lively jumble of easels and painting materials that she had seen in the teaching studio. There, among the half-finished canvases, she sensed the potential of 'a larger, freer, and more earnest artistic world'. But she bitterly acknowledged that it was a world that 'one's *woman*hood debars one from joining'. Howitt left the academy 'sick at heart', lamenting, 'Oh! how terribly did I long to be a man so as to paint there.'[1]

In common with most aspiring female artists of her day, Howitt had to cobble together an art education. At the time of the lecture, she was studying at an art school in London established by artist Henry Sass. This private academy took in both male and female students, but life classes, featuring a nude or partially clothed model, were open only to men. Male students often attended Sass's academy to prepare for the Royal Academy Schools'

entrance examination; barred from the life classes at Sass's school, women with similar ambitions were at a disadvantage (see page 13). Howitt would have found a similar situation in Paris, where the École des Beaux-Arts, the official art academy, simply did not accept women. A few artists did open their studios for female classes; such classes excluded male students, but the teacher was always a man. Howitt could also have hired a private tutor to give her lessons at home.

In 1850 Howitt left London for Munich, where she studied under the prominent muralist Wilhelm von Kaulbach. She also wrote a series of lively articles about life in the German city, which, following her return to London, were published as *An Art-Student in Munich* (1853). The book was a bestseller, but it did not answer the question that had plagued her since that lecture at the Royal Academy: what was the danger in allowing women to work wherever they desired?

In modern parlance, the word 'danger' warns of a potentially perilous situation. To confront danger is to expose oneself to harm, to face a threat – either known or undefined – and risk the consequences. But the origin

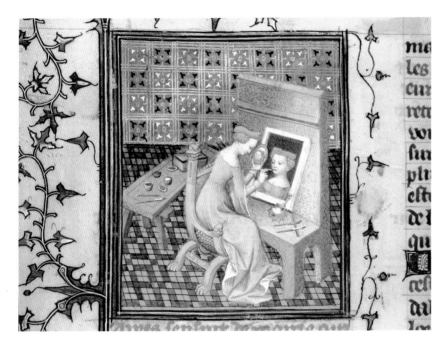

French School
St Marcia Painting a Self-Portrait, from
De claris mulieribus by Giovanni Boccaccio
(MS Fr 124220 f.101v)
15th century
Vellum
Dimensions unknown
Bibliothèque Nationale de France, Paris

of the word adds another dimension. The English 'danger' derives from the Old French *dangier*, which, in turn, has its origins in the Latin *dominiarium*, a derivative of *dominium* (lordship or sovereignty) and *dominus* (lord or master). From the medieval era until the nineteenth century, 'danger' meant the power of a lord or master, one who has jurisdiction or dominion.[2] It was this aspect of danger that Howitt, and generations of women both before and after her, confronted when they aspired to be artists, for, historically, power in the art world has rested in the hands of men.

Until relatively recently, the history of art was a celebration of male talent and accomplishments, lauding the great men – the 'Old Masters' – who made the great art that was displayed to a mostly male audience in male-run institutions. Men ran the studios and taught in the schools, and, for the most part, it was men who organized the exhibitions, wrote the reviews and bought works of art. But women have always had a role in the arts, often working behind the scenes or in opposition to prevailing attitudes and practices. For a woman to seek recognition in this masculine domain took courage; she had to steel herself for confrontation and be ready to defy conventions and expectations. To secure her place in the art world, a woman had to be willing to court danger.

Prior to the Renaissance, the presence of women artists in documents or imagery is rare. When a woman's name or image does appear, myths and traditions often obscure the scant factual evidence. Take, for example, the subject of St Marcia painting her own portrait (above). Italian writer Giovanni Boccaccio mentions both Marcia and the portrait in *De claris mulieribus* (On famous women; 1361), a compendium of the lives of such notable women – historical, legendary and mythological – as Eve, Venus, Sappho, Semiramis and Pope Joan. Although Boccaccio informs his reader that 'art is very much alien to the mind of women' because it demands 'a great deal of talent' of the sort women rarely possess, he singles out three women artists: Thamyris, Irene and Marcia.[3] Their accomplishments, as well as their names, are suspiciously close to those of the women artists mentioned by the Roman writer Pliny the Elder in his *Natural History* (AD 77) as an addendum to the section on art techniques and famous artists – all

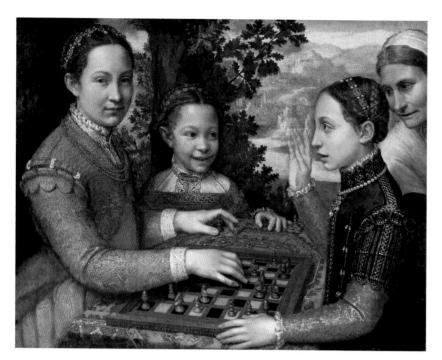

Sofonisba Anguissola (*c.* 1532–1625)
The Chess Game
1555
Oil on canvas
72 × 97 cm (28⅜ × 38¼ in.)
Muzeum Narodowe w Poznaniu, Poland

male – of Greek and Roman origin. In common with Pliny's Timarete and Eirene, Boccaccio's Thamyris and Irene are daughters of painters. But Pliny does not cite the parentage or the tutor of Iaia of Kyzikos, who appears to be the prototype for Boccaccio's Marcia.

The accomplishments of Iaia of Kyzikos and Marcia are strikingly similar. They have mastered their craft; they work with uncanny speed and facility. Both won acclaim for their portraits of women, and both painted their own portrait with the aid of a hand-held mirror. A few of the late fourteenth- and fifteenth-century illuminated manuscripts of *De claris mulieribus* include an image of Marcia painting her own portrait. The French version shown here (page 7) is particularly detailed, depicting Marcia's palette and brushes close at hand on the ledge of her easel, and several little bowls of pigment and a few extra brushes on a table near by. Marcia herself is well but simply dressed; her hair is braided and tucked up under a cap. She is ready to begin her work, and her neat appearance matches her focused demeanour. Marcia shares another element of her biography with Iaia. Boccaccio notes that

she never married; in fact, her decision to remain chaste extended even to her subject matter. Study of the male form might have led her to compromise her honour, so rather than painting men 'imperfectly' without a model, she simply abstained from painting them.[4]

In the first edition of his *Lives of the Artists* (1550), Italian artist and art historian Giorgio Vasari (1511–1574) recognizes one woman, Properzia de' Rossi (*c.* 1490–1530), a sculptor who gained fame in her native Bologna. Although Vasari praises her talent, he also refers to her great personal beauty and her unrequited love for a handsome young man. In summarizing her career, Vasari observes that Properzia 'came to succeed most perfectly in everything, save in her unhappy passion'.[5] Vasari increased the number of women in the second edition of *Lives* (1568), but did so by appending some of their names and accomplishments to Properzia's entry, and by citing others in entries on their fathers or teachers.

Clearly, for a woman artist to succeed, she needed to work in the company of men. Both Barbara Longhi (page 20) and Lavinia Fontana (page 66) were the daughters of successful painters. Their fathers were

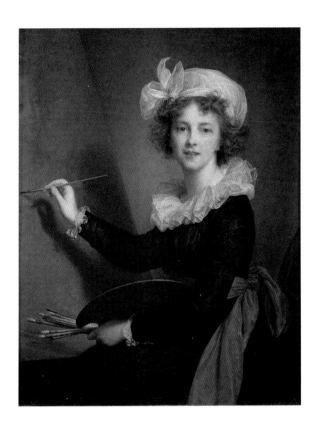

Elisabeth Vigée-Lebrun (1755–1842)
Self-Portrait
1790
Oil on canvas
100 × 81 cm (39⅜ × 31⅞ in.)
Galleria degli Uffizi, Florence

their teachers, and they worked in their fathers' studios alongside their brothers and the other male apprentices. For centuries, having a male artist in the family – father, brother, uncle or even stepfather – was the most common means by which a woman entered what for most women was an uncommon profession. But for every woman whose name and accomplishments were recorded, countless others have gone unrecognized. And even when a woman did enjoy a measure of fame, all too often her work and reputation were evaluated as extensions of her father's own career. Sixteenth-century painter Marietta Robusti (page 42), daughter of Jacopo Robusti – otherwise known as Tintoretto – enjoyed both acclaim and good commissions during her lifetime. Her reputation endured into the seventeenth century, when Italian artist and writer Carlo Ridolfi included her in a biography of her father and brother (1648). But, even in the section devoted to Robusti's career, Ridolfi stresses Tintoretto's importance, concentrating as much on his paternal devotion – his pride in her talent and his heartbreak at her early death – as on her own artistic achievements.

Some women were able to pursue training and a career in the arts outside their family's circle. Sofonisba Anguissola (page 130) was the eldest of six daughters of a noble Italian family in Cremona. In common with many well-born young women of the sixteenth century, she and her sisters received an education that included training in music and the arts. Anguissola and her sister Elena, the second daughter, studied painting under the highly regarded master Bernardino Campi. Even at a young age, Anguissola had confidence in her own talent and regarded her ability as more than just the accomplishment of a well-bred lady. She painted a number of self-portraits – depicting herself with books and playing the clavichord, as well as painting – and often inscribed her works with references to her skill and precociousness.[6] By the time she painted *The Chess Game* (opposite), she had left her home in Cremona to seek further training in Milan. The painting features three of her younger sisters: (from left to right) Lucia, Europa and Minerva. Although it is an intimate family scene, the composition itself is complex, featuring four distinct portraits (the elderly woman is a household

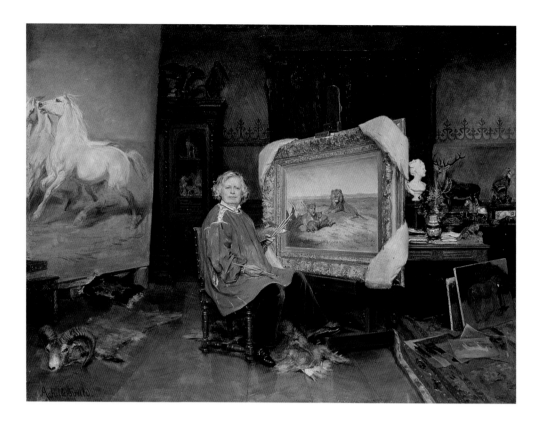

servant who appears in other paintings), the still-life arrangement of the chess board and pieces on a Turkish carpet, and a naturalistic landscape that sweeps into the distance. Combining these different elements proclaimed her mastery – equal to that of any man in her field – and within four years of completing the painting, Anguissola had moved to Madrid to take up a position in the Spanish court.

There were also women who outshone their male colleagues and mentors. Maria Sibylla Merian (page 44) learned to paint flowers in the studio of her stepfather, Jacob Marrel. In 1665 she married Johann Andreas Graff, another of Marrel's pupils. Their rivalry and conflicting interests eventually led Merian to leave him and move to Amsterdam, where she gave free rein to her interest in entomological illustration. She divorced Graff in 1699 and then travelled to Suriname, in South America, to do the research for her acknowledged masterwork of art and natural science, *Metamorphosis insectorum Surinamensium* (1705). In the mid-eighteenth century Joseph Johann Kauffman enjoyed modest success as a muralist and portrait painter, but his

daughter, Angelica (page 24), whom he trained, achieved international success. Louis Vigée, a pastel portraitist, gave his daughter, Elisabeth (pages 9 and 136), her initial training, but she quickly moved on to work in the studios of such prominent painters as Gabriel-François Doyen, Joseph Vernet and Jean-Baptiste Greuze. Within a few years of her father's death in 1767, she was able to support the family with portrait commissions, and by 1779, just three years after marrying art dealer Jean-Baptiste-Pierre Lebrun, Elisabeth Vigée-Lebrun had secured her first commission to paint Marie Antoinette, the queen of France.

In the following century Rosa Bonheur (page 27) also launched her career from her father's studio, and her reputation quickly overshadowed his. She won top prizes at the Paris Salon, gained international fame as an *animalière* – a painter of animals, traditionally a male-dominated profession – and, in 1895, was made an *officier* of the Légion d'Honneur by the French Republic, the first woman to be so honoured. Bonheur was uncompromising in the way she forged both her career and her professional identity (above). In 1842,

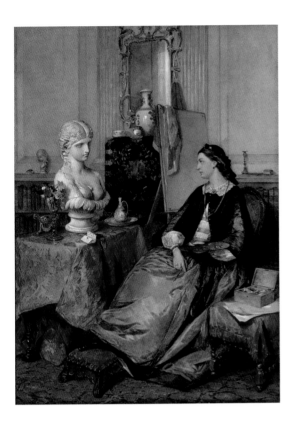

OPPOSITE
Georges Achille-Fould (1865–1951)
Rosa Bonheur in Her Studio
1893
Oil on canvas
91 × 124 cm (35¾ × 48¾ in.)
Musée des Beaux-Arts, Bordeaux

LEFT
Octavius Oakley (1800–1867)
A Student of Beauty
1861
Pencil, gouache and watercolour on paper
76.2 × 54.6 cm (30 × 21½ in.)
Private collection

the year after her debut at the Salon, she began to work in male attire, explaining that such garments made it possible for her to sketch at cattle markets and slaughterhouses without drawing unwarranted attention. She refuted presuppositions about suitable subjects for women artists by making her name in a masculine field, and by painting large and exotic animals as ably as any man. Bonheur never put up a false pretense of humility; she was secure in her ambitions and proud to present her works – and her self – as an accomplished professional. She blurred the long-standing boundary in the arts that separated female endeavour from masculine accomplishments, but few women of her generation were as bold or as successful.

It is important to acknowledge that during the nineteenth century women were encouraged to cultivate their artistic skills. In middle-class and affluent homes, a young woman's ability to draw or paint in watercolour was deemed a valued and genteel quality. Even Queen Victoria took art lessons, demonstrating a natural aptitude for landscape views and portraits. The appropriate role was that of the 'lady artist', well aware

of her limitations and fully content with her amateur status. English watercolourist Octavius Oakley portrays this feminine ideal in *A Student of Beauty* (above). A young woman, palette in hand, studies a Roman bust on a nearby table. Her paint box is open, and she has already made a few faint lines on the paper tacked to her easel. She hesitates, as if waiting for inspiration. Her demeanour, as well as her garments and the setting, stand in striking contrast to Bonheur's audacious assertion of her own power and identity. Oakley's fair painter sits in a parlour, not a studio. Unlike Bonheur, who favours trousers and a smock as working attire, Oakley's painter wears a conventional silk gown. The black lace mantle draped over her shoulders would offer little protection from spills and spatters. Her garments suggest that her work is neither untidy nor strenuous; in fact, every aspect of the painting – the well-appointed setting, the woman's stylish attire, even her languid pose – reinforces the assumption that Oakley's 'Student of Beauty' pursues her art for pleasure, rather than as a profession.

Whether as an ambitious aspiring professional or a genteel amateur, studying the human figure from a live

Johann Zoffany (1733–1810)
The Academicians of the Royal Academy
1772
Oil on canvas
101.1 × 147.5 cm (39¾ × 58⅛ in.)
The Royal Collection, London

model was another boundary that women found hard to cross. In his account of Marcia's achievements, Boccaccio observes that even though she lived in 'antiquity' she avoided representing the male nude; her 'chaste modesty' prevented her from studying the human form from life.[7] Over the centuries the belief that it was indecent for a woman – artist or otherwise – to observe any nude or partially clothed figure prevailed, leading to the long-standing practice of substituting sculpture for the live model. Renaissance artist Lavinia Fontana, credited with painting the earliest known nude by a woman, painted her own portrait seated next to a collection of small casts of antique sculpture;[8] the proportions and posture of the figure in her *Minerva Dressing* (page 67) suggest that she was probably working from such sculpture, rather than a model. The Roman bust depicted in *A Student of Beauty* reveals how long this practice endured. Undoubtedly, if women were working in men's studios, they would have had access to – or at least a glimpse of – a live model in some state of undress, but while a male artist was encouraged to look at bodies, a female artist learned that doing the same sullied her reputation.

The rise of academic training in the eighteenth century made it increasingly difficult for women to study the human figure. For example, the Royal Academy of Arts counted two women – Angelica Kauffman and Mary Moser – among its founding members. However, in a group portrait of the academicians in the studio by German artist Johann Zoffany (opposite), neither Kauffman nor Moser appears to be present. It is a lively, all-male gathering. A few of the men sketch while others converse, but the majority direct their attention to one side of the studio, where George Moser, Mary's father and Keeper of the Academy, helps a nude male model assume a pose. Another model disrobes in the foreground, preparing for his turn on the stand. Under such circumstances Kauffman and Moser would not have been present, but Zoffany includes them by proxy, placing their portraits – Kauffman's on the left, and Moser's on the right – on the wall above the model's platform. It was not until 1893 that the Royal Academy allowed its female students to participate in life classes, and then the classes were segregated by gender.

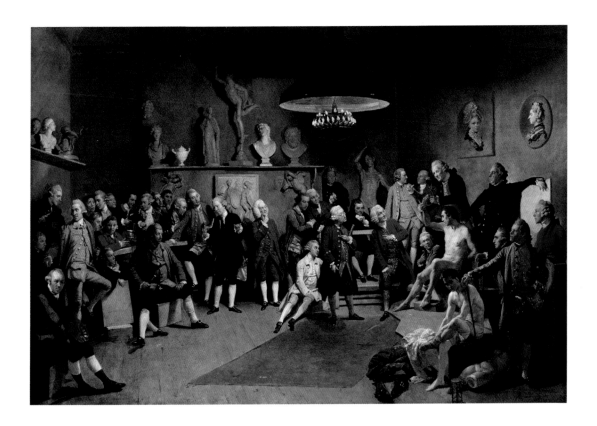

For much of the nineteenth century the major academies did not even admit female students. There was nothing in the charter of the Royal Academy forbidding women from enrolling in classes, but women who applied were routinely turned down until 1860, when an application was accepted from 'L.H.', who turned out to be Laura Herford. After that, the academy regularly admitted female students, but in far fewer numbers than their male counterparts. Following the death of Kauffman and Moser, the next woman to attain the status of Royal Academician was Laura Knight. She received the honour in 1936 at the age of fifty-nine, seven years after being made a Dame. In Paris, the École des Beaux-Arts did not accept female students until 1896, but in the second half of the nineteenth century aspiring women artists could enroll in such private studios as the Académie Julian or the Académie Colarossi, or take private lessons with such prominent painters as Thomas Couture or Charles Chaplin, both of whom offered classes for women. Mariya Bashkirtseva (page 70) found the environment of the women's studio at the Académie Julian essential to developing her

identity as a working artist. There, in the studio, 'one is no longer the daughter of one's mother, one is one's self – an individual – and one has before one art and nothing else. One feels so happy, so free, so proud.'[9]

Even at the turn of the twentieth century, women were hampered by limited access to life classes and nude models. Some women, including Camille Claudel (page 35), Gwen John (page 73) and Suzanne Valadon (page 74), worked as models to gain first-hand studio experience, as well as to supplement their meagre incomes. Countless others informally posed for their fellow female artists, both in the artists' private rooms and in studios. In a self-portrait of 1913 (page 2), Laura Knight included an image of her friend and colleague Ella Naper on the model's stand. At this point in her career, there was no question of Knight's professional identity; she had been teaching since 1894 and exhibiting at the Royal Academy since 1903. Even so, her self-portrait made a bold statement: by depicting herself with her model, she asserted her power as an artist and confronted the age-old cliché of the masterful male artist painting the obliging female nude. The work is big in scale and bold in colour,

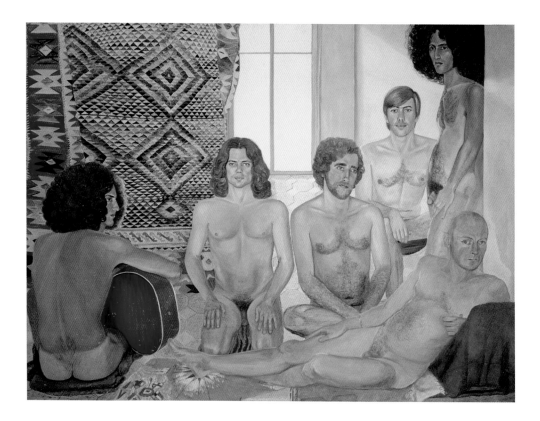

and Knight's own figure, in a rumpled red cardigan, is positioned so as to force the viewer to look over her shoulder. Whether on the stand or on the canvas, the model is seen from Knight's perspective. Knight has seized the narrative of the traditional relationship between artist and model by asserting the right of her gaze.

As a child, Judy Chicago (page 96) took art lessons at the Art Institute of Chicago, and she acknowledges that the 'wonderful paintings' she saw in the galleries inspired her. At the same time, she also became painfully aware of the way in which men depicted women, and she knew, even then, that she 'did not want to become the object of the male gaze. Rather, I wanted to be the one who did both the gazing and the painting.'[10] Those women artists who chose to gaze upon and depict the female form – including their own – released the female body from its function as a personification of ideal beauty, recognizing its infinite variation and expressive potential. Such artists as Jenny Saville (page 80) and Catherine Opie (page 122) have explored the diverse appearance of individual bodies, challenging conventional ideas about what is normal and what is

beautiful. Alice Neel (page 79) and Frida Kahlo (page 146) used images of themselves to chart their own life experiences and insights, as has Renée Stout (page 118). And, in *The Turkish Bath* (above), Sylvia Sleigh wittily subverted the trope of male artist and female model by restaging Jean-Auguste-Dominique Ingres's famous *Turkish Bath* (1863). Sleigh admitted that her motivation was, in part, to challenge the power of the male gaze, the fact that women 'had always been painted as objects of desire'. Although she did not mind 'the desire part', she disliked the dehumanized concept of the body as object and sought to create an alternative.[11] By replacing Ingres's imagined women of the harem with individualized depictions of contemporary men – the sitters included her husband and the couple's friends – Sleigh countered the dominance of the male gaze and shattered the obsolete fantasy of orientalism.

Since the early years of the twentieth century, women artists have taken up subjects, as well as media and techniques, that had previously been regarded as inherently masculine and, through revision and repurposing, have made them their own. But there

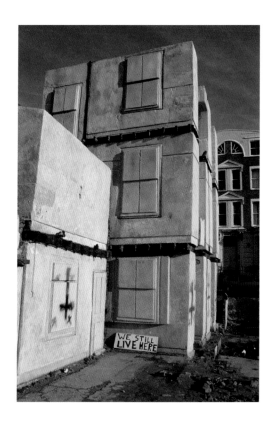

OPPOSITE
Sylvia Sleigh (1916–2010)
The Turkish Bath
1973
Oil on canvas
193 × 259.1 cm (76 × 102 in.)
David and Alfred Smart Museum of Art,
The University of Chicago; purchase of Paul
and Miriam Kirkley Fund for Acquisitions

LEFT
Rachel Whiteread (born 1963)
House
1993 (destroyed 1994)
Concrete
Dimensions unknown

are images and practices that have long been seen as 'feminine', and these, too, have been redefined through inventive interpretations and new points of view. In the realm of needlework and fabric arts, Sonia Delaunay (page 50) bridged the divide between art and commerce with textile and garment designs that embodied the same modernist ideals as her paintings. Isabelle de Borchgrave (page 62) substitutes paper for fabric and, in a near magical transformation, creates sculptures inspired by iconic garments portrayed in paintings, as well as by landmark designs in the history of dress. There are, however, few concepts as strongly linked with women as the home. Over the centuries domestic life, as well as the domicile, has been seen as a conventionally feminine domain, prompting contemporary artists to engage with domestic spaces in ways that upend and even destabilize all previous assumptions (see page 126). In 1993 Rachel Whiteread created *House* (above) by pumping liquid concrete into an abandoned three-storey house in London's East End before stripping away the exterior walls, leaving an impenetrable white-grey block, with the now useless forms of windows and doors impressed into

its surface. Critic Andrew Graham-Dixon called the work 'the opposite of a house'.[12] It looked like a house, but no one could enter, no one could live there. And it stood like a spectre at 193 Grove Road, the sole survivor of a demolished terrace, until January 1994, when it was razed to the ground by the local council.

There is an implicit risk in creating art that challenges assumptions and defies expectations. Throughout history women artists have grappled with exclusion in every imaginable form, and have faced down limited options, public anger and professional scorn, as well as condemnation and censorship. Time and again, women artists have chosen audacious action over safe acceptance, courting danger through political expression (page 111), provocative subjects (pages 112 and 125) and giving a voice to the voiceless (page 102). Women have even revised the canonical history of art, as seen in Judy Chicago's monumental *Dinner Party* (page 97), a tribute to renowned and unsung heroines of the international Women's Movement that celebrates women's work and women's art by carving out a space for women in the historical narrative.

THE ADVANTAGES OF BEING A WOMAN ARTIST:

Working without the pressure of success
Not having to be in shows with men
Having an escape from the art world in your 4 free-lance jobs
Knowing your career might pick up after you're eighty
Being reassured that whatever kind of art you make it will be labeled feminine
Not being stuck in a tenured teaching position
Seeing your ideas live on in the work of others
Having the opportunity to choose between career and motherhood
Not having to choke on those big cigars or paint in Italian suits
Having more time to work when your mate dumps you for someone younger
Being included in revised versions of art history
Not having to undergo the embarrassment of being called a genius
Getting your picture in the art magazines wearing a gorilla suit

A PUBLIC SERVICE MESSAGE FROM **GUERRILLA GIRLS** CONSCIENCE OF THE ART WORLD

LEFT
Guerrilla Girls
The Advantages of Being a Woman Artist
1988
Offset lithographic poster
Dimensions variable
Courtesy of guerrillagirls.com

OPPOSITE
Marina Abramovic (born 1946)
The Artist is Present
14 March – 31 May 2010
Installation view of performance
The Museum of Modern Art, New York

But few artists have matched the audacity of the Guerrilla Girls (page 120), an anonymous collective of women artists who first banded together in 1985 to expose discrimination against women in the art world. In a send-up of the 'masked avenger' figure from popular culture, they hide their identities behind gorilla masks when appearing in public and use the names of deceased women artists when giving interviews. Their methods are subversive and irreverent; they willingly play with danger, but they are hardly pranksters. Using posters, postcards, billboards and direct action, the Guerrilla Girls have appropriated the methods of popular media and street theatre to unmask the vestigial inequities in the art world, including the ratio of works by women to those by men in major museums, the limited number of women represented by prominent galleries and the disproportionate earning power of men over women. They have called *The Advantages of Being a Woman Artist* (above) their 'all-time favorite' poster, slyly explaining that they created it 'to encourage female artists to look on the sunny side'.[13] Their art is portable and infinitely reproducible, and they have produced translated versions of their work to carry their message beyond the English-speaking world. More than a quarter of a decade since the group's formation, its members remain the conscience of the art world. Their work continues, as new members – always anonymous – take up the cause to confront discrimination based on racism, tokenism, sexism and sexual orientation wherever it exists in society, as well as in the art world's institutions.

On 14 March 2010 performance artist Marina Abramovic (page 116) sat down at a table located in an atrium at the Museum of Modern Art in New York. She was beginning a new performance piece, created especially for *The Artist is Present*, the museum's retrospective of her work.[14] For more than three decades, Abramovic has stood at the vanguard of performance art. Whether working with a partner, most often Frank Uwe Laysiepen (Ulay), or on her own, Abramovic has pushed the limits of what her audience will tolerate and what her body can endure. And she has never drawn back from danger. In performance pieces that have disturbed and repelled her viewers, yet held them spellbound and silent, she has remained still in uncomfortable positions,

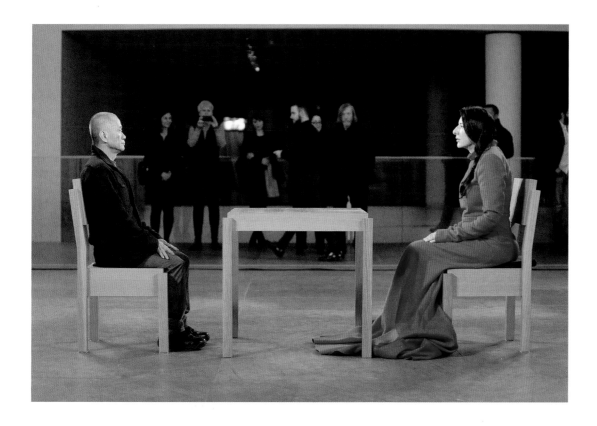

exposed her skin to extreme heat and cold, wounded her body and submitted it to manhandling, and abstained from food and water. For the retrospective, Abramovic had trained a select group of performance artists and dancers to re-create works from the whole of her career.[15] She, too, would be engaged in performance throughout the two-and-a-half-month exhibition, seated at that table. And anyone was welcome to sit down opposite her in an empty chair placed on the other side (above).

The piece had its origins in a performance that Abramovic had created with Ulay decades earlier. For *Nightsea Crossing* (performed twenty-two times between 1981 and 1987), she and Ulay sat unmoving on opposite sides of a table. They remained silent and abstained from food. The length of the performance varied from twenty-four hours to sixteen days, but the two artists were always in place before the public entered, and remained in place after the public departed.[16] The new iteration featured marked differences. The colourful clothes that Abramovic and Ulay had worn for *Nightsea Crossing* were replaced by stark, simple floor-length gowns in red, black or white. Endurance was not an

essential feature; Abramovic left the table when she needed a break. But the biggest change was that empty chair. Visitors to the exhibition could sit there for as long as they desired. They could look at her or look away, while she sat composed, in perfect silence, willing to submit to their scrutiny. Those who chose to sit down often stayed for as long as fifteen or twenty minutes, and many of them found it to be a profoundly moving experience, one that often culminated in an emotional catharsis and even tears.[17] Critic Arthur Danto described the experience as magical, recalling that the artist appeared to be 'luminous', as if in a 'shamanic trance'.[18] Some visitors avoided the chair; some even found it hard to watch as Abramovic sat with those willing to join her. But, whether a visitor chose to sit with her or not, the artist was granted her right to assert her presence, and, through that, she made a bold and powerful statement. By just being there, Abramovic embodied the tantalizing danger of a woman artist at work.

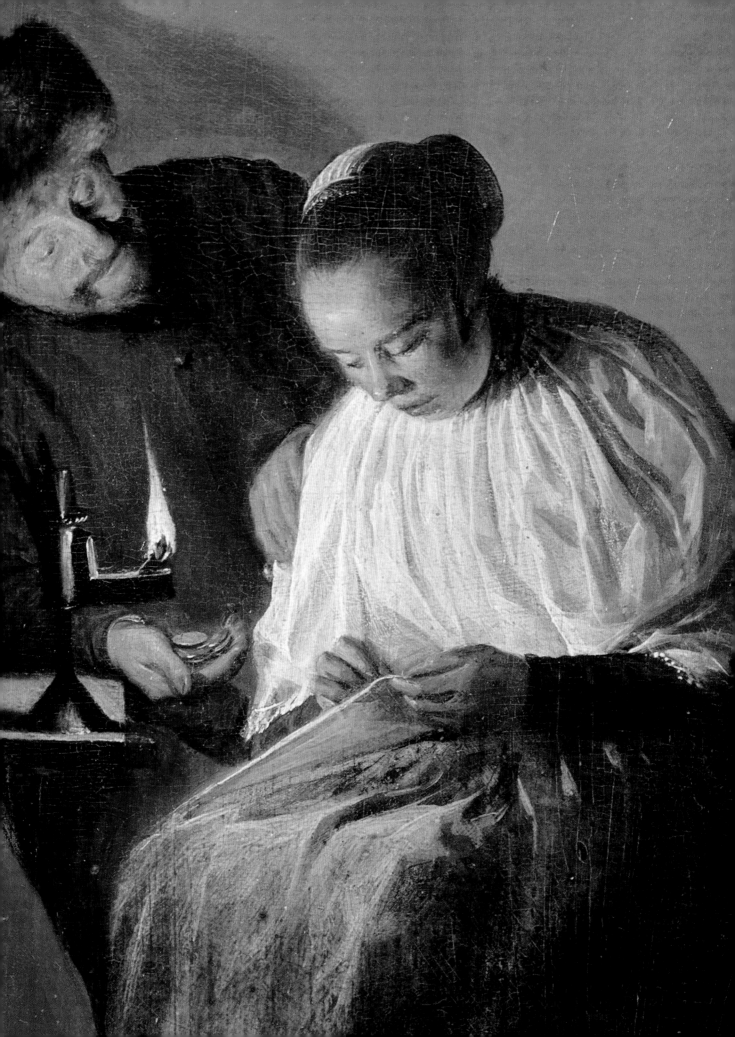

Over the centuries the art world has been a predominantly male domain. Men were the masters in the workshops and the apprentices in training. They built the academies, wrote the history and criticism, and earned fame for their brilliance and innovation. But the women were always there, sometimes in the wings, but often working right beside the men.

The careers of many female artists began in the studio of a male relative; Barbara Longhi and Angelica Kauffman (pages 20 and 24, respectively) were tutored by their fathers. Rebecca Solomon's first teacher was her mother, but her brothers helped her to launch and sustain her career (page 28). Guilds and professional associations were reluctant to accept women, and even when they were admitted, they had to fight to defend their privileges (page 22). Women's work was judged by male standards; critics thought it high praise to cite the presence of a 'manly touch'. And when women outshone men, critics expressed astonishment that they could compete in a masculine arena (page 27).

In the late nineteenth century the changing art world brought new opportunities; Berthe Morisot and Mary Cassatt (pages 31 and 32, respectively) gained acclaim through association with the Impressionists. But many women came to realize that, in order to assert their own identity, they had to step out of the shadow of their male colleagues, whether they were their husbands (pages 36 and 39), their lovers (page 35) or their friends. Through daring, talent and plain hard work, women artists challenged male dominance and forged their own careers with – and without – the company of men.

In the Company of Men

As the daughter of a prominent painter, Barbara Longhi took advantage of a rare opportunity for women of her era: to train alongside the male apprentices in an artist's workshop. Her father, Luca Longhi (1507–1580), worked in a distinctive Mannerist style, and his Ravenna-based shop produced large altarpieces that graced churches throughout the Emilia-Romagna region of Italy. As master of the shop, Longhi's father would have guided his daughter through every stage of studio practice, beginning with sweeping the premises and culminating in assisting with the completion of larger commissions. Understandably, her early work resembles that of her father, but in the decade after his death her mature style emerged.

Among the fifteen works firmly attributed to Longhi – some signed 'B.L.F.', the 'F' standing for *fecit*, the Latin for 'made it' – twelve portray the Madonna and Child. This painting illustrates the certainty of hand and brilliance of colour that distinguished her later work from her father's œuvre. And although she never left Ravenna, elements of her style reflect knowledge of the latest innovations in aesthetics and techniques: the deft stroke and golden illumination of Correggio, the naturalistic beauty of Raphael's Florentine women, and the expansive landscape view associated with Leonardo da Vinci.

Following her father's example, Longhi painted several altarpieces, including *The Healing of St Agatha* (*c.* 1595) and the *Cappuccini Altarpiece* (1595), but scant documentation makes it difficult to reconstruct either the extent of her business or the identity of her patrons. Most of her known works are small, suggesting a private clientele. Although her ambitions may have been constrained by the fact that she was the daughter rather than the son of an admired painter, her promising talent caught the attention of Giorgio Vasari, who noted in his *Lives of the Artists* that Luca Longhi's daughter 'draws very well' and exhibits 'grace and excellence of manner'.[1]

Barbara Longhi

Barbara Longhi (1552 – *c.* 1638)
Virgin and Child with St John the Baptist
c. 1595–1600
Oil on canvas
45.7 × 35.6 cm (18 × 14 in.)
Gemäldegalerie Alte Meister, Staatliche
Kunstsammlungen, Dresden

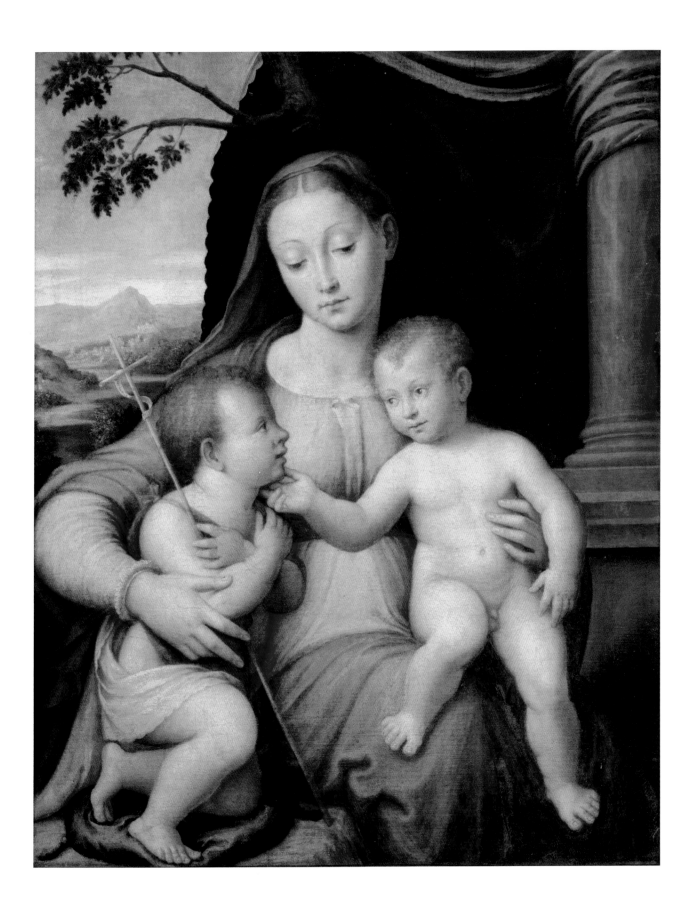

Judith Leyster, born in Haarlem in The Netherlands, embellished her monogram with a shooting star, playing on the literal meaning of her surname ('lodestar' or 'leading star'). But the symbol also reflected the confidence of an accomplished woman in a man's profession. Before the age of twenty-five Leyster gained notice for her subjects of card sharps, drinkers and revellers painted in a vigorous hand. In 1633 she became the first female member of the Haarlem Guild of St Luke, which allowed her to establish her own workshop and hire apprentices. She even successfully sued Frans Hals (1581/85–1666) for tuition compensation when one of her pupils abruptly left her studio to take a position with the pre-eminent painter.

Although many of Leyster's works resemble those of Hals in subject and style – so much so that scholars speculate that she spent time in his workshop – this depiction of an ambiguous encounter between a man and a woman reveals a unique perspective on a standard motif. At first glance, the man offering gold coins to the woman evokes the popular subject of a proposition in a brothel.[2] But, unlike the seductive and salacious figures typical of the motif, this woman is modestly dressed and fully absorbed in her sewing. Needlework was women's work in The Netherlands of the 1600s, and it exemplified domestic industry and female virtue. Perhaps the man is proposing to rather than propositioning this worthy woman, using the coins to represent the financial security he would bring to the marriage. Her adamant disinterest recalls an epigraph in an emblem book (a collection of didactic illustrations and texts) by the seventeenth-century Dutch statesman and poet Jacob Cats: 'No pearl should be bought at night / no lover should be sought by candlelight.'[3] In this context, Leyster turns the motif around, urging the woman to seize the power of choice and wait for the clarity of day before making her decision.

Judith Leyster

Judith Leyster (c. 1609–1660)
Man Offering Money to a Young Woman
1631
Oil on panel
30.9 × 24.2 cm (12⅛ × 9½ in.)
Mauritshuis, The Hague

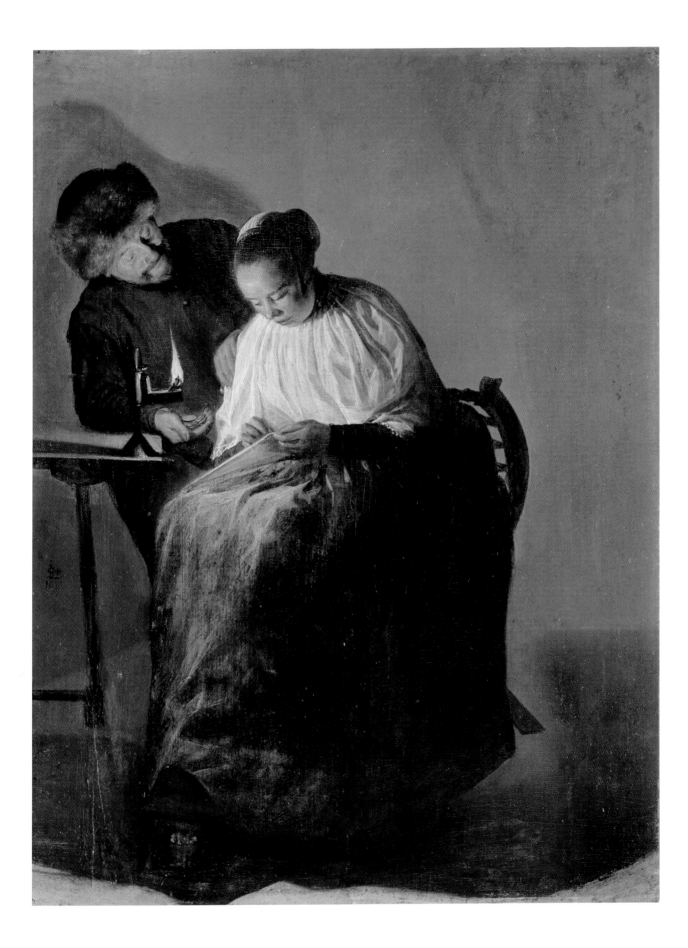

As a child prodigy, Angelica Kauffman made a decision that defined her destiny. Her sweet singing voice – as well as her beauty – would have easily led to fame on the concert stage, but, according to her first biographer, Giovanni Gherardo de Rossi, she rejected the 'flower-decked path of music' for 'the thorny path of painting'.[4] Her father, Joseph Johann Kauffman (1707–1782), a successful portrait painter and muralist, proved a willing mentor. He trained her and encouraged her high aspirations, and, in his company, she entered the international – and exclusively male – artistic circles of Florence and Rome. She moved to London in 1766, and although she had built a considerable reputation as a portraitist, she now sought recognition in the highly esteemed realm of history painting.

Kauffman, Swiss by birth, asserted her new identity in 1769, at the first exhibition of the newly established Royal Academy of Arts in London. One of two female founding members (with Mary Moser; see page 12), she submitted grand mythological subjects in the neoclassical mode and was immediately hailed as a master of both subject and style. Her career rivalled that of any male artist of her generation, and when she painted autobiographical subjects, she deftly employed the language of classical art, as seen in this late-career self-portrait celebrating the choice she had made in her youth.[5]

Kauffman derived her subject from the classical allegory 'The Choice of Hercules', in which the demigod chooses to ally himself with virtue and a life of heroic struggle rather than vice and a life of pleasure, each option represented by an unnamed woman. Clad in white, the young Kauffman bids a wistful farewell to Music as she turns to follow Painting towards the rugged mountains that loom in the distance. Kauffman makes her point with confidence and wit. She had surpassed most men in her career; now, she reinterprets a masculine myth to commemorate her triumph.

Angelica Kauffman

Angelica Kauffman (1741–1807)
Self-Portrait of the Artist Hesitating Between the Arts of Music and Painting
1794
Oil on canvas
147.3 × 215.9 cm (58 × 85 in.)
National Trust, Nostell Priory, Wakefield, West Yorkshire

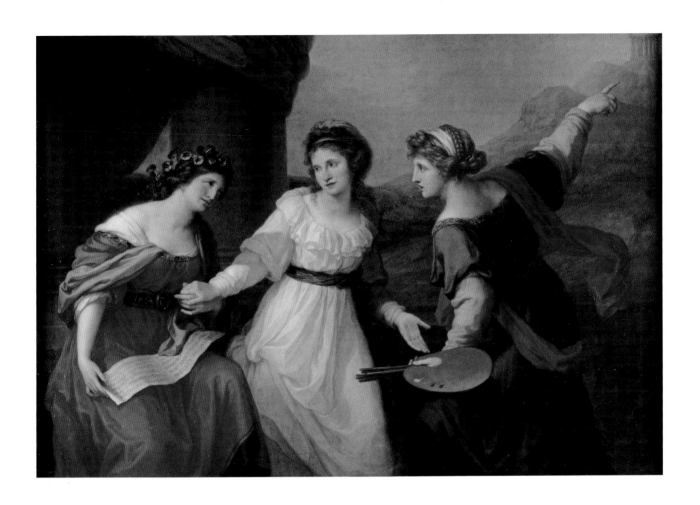

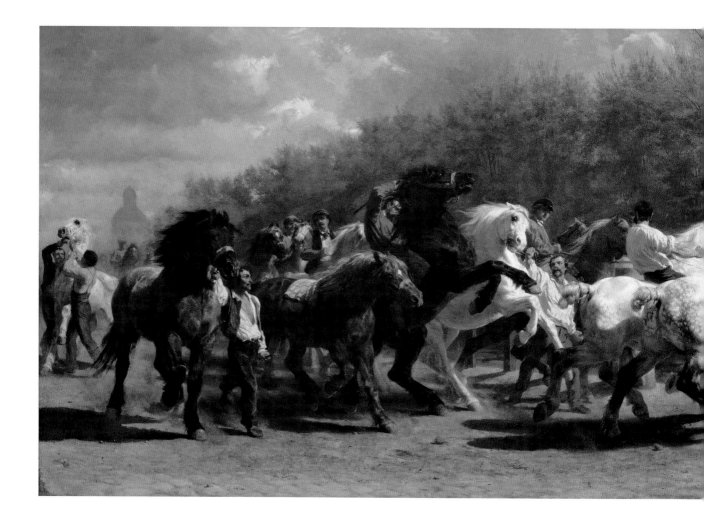

Rosa Bonheur

Rosa Bonheur (1822–1899)
The Horse Fair
1853
Oil on canvas
244.5 × 506.7 cm (96¼ × 199½ in.)
The Metropolitan Museum of Art,
New York

In 1855 the French painter and sculptor Rosa Bonheur travelled to London to attend an exhibition organized by her art dealer, Ernest Gambart. Two years earlier she had debuted her painting *The Horse Fair* at the Paris Salon, where it had received rave reviews, and Gambart predicted that it would be the highlight of his *Second Annual Exhibition of the French School of Fine Arts in London*, held at his gallery on Pall Mall. But the artist's celebrity preceded her arrival, and she proved as great an attraction as her grand-scale canvas. Art critic William Rossetti hailed her as a 'renowned and phenomenal visitor', but he also urged his countrymen, while they 'are making haste to do her honour', to consider the timely issue 'of what likelihood there is that women should compete in the fine arts with men'.[6]

Bonheur never questioned her right to compete with men. Her father, the painter Raymond Bonheur (1796–1849), insisted on an equal education for his daughters and sons, in accordance with his Saint-Simonian beliefs.[7] By the age of fourteen, Bonheur had begun to pursue a career as an *animalière*. Although women already painted small animals – domestic pets, birds and fish – Bonheur's focus on cattle and horses was rare. She insisted on studying her subjects from life, and in order to make her way unnoticed among the men at the cattle markets and slaughterhouses, she began to wear trousers. She also rode astride rather than side-saddle, cropped her hair and smoked cigarettes. Her assertive eccentricities drew as much attention as her talent.

Bonheur based *The Horse Fair* on extensive sketches made on-site at the horse market near the Hôpital de la Salpêtrière in Paris. The vast scale of the finished canvas reflected her confidence as well as her ambition to compete in a male-dominated genre. Even Queen Victoria admired her work: during the London exhibition, *The Horse Fair* was taken to Buckingham Palace for a private view.[8]

Born in London, Rebecca Solomon was taught how to paint by her mother, an accomplished watercolourist, but she relied on the male members of her family to help her negotiate the Victorian art world. Her older brother, Abraham (1824–1862), enjoyed a solid career painting contemporary genre scenes, and Solomon shared his studio for more than a decade (1851–62). As his assistant, she studied his technique and copied his paintings, but she also exhibited her own work, earning recognition for literary and biblical subjects. When Abraham died, Solomon moved into the studio of her younger brother, Simeon (1840–1905), and she remained with him until 1873.[9] Simeon had taken his career in a different direction, celebrating his Jewish heritage in Old Testament subjects and allying himself with the Pre-Raphaelites. Solomon promoted his career, modelled for his friends and worked as a copyist for the painters John Everett Millais and John Phillip.

Throughout it all, Solomon maintained her independence as a professional painter. She regularly exhibited her work at the Royal Academy of Arts and other British venues. In addition to copy work and modelling, she supplemented her income by producing illustrations for popular journals, including *London Society* and the *Churchman's Family Magazine*. Solomon's work was well reviewed, but, as was the case for many women painters of her day, critics thought it high praise to cite a 'firm and masculine' quality in her work, which would 'scarcely be pronounced the work of a lady'.[10]

The Wounded Dove reflects the rising influence of Aestheticism, an innovative belief in art for art's sake advocated by Solomon's brother Simeon and other members of the Aesthetic Movement. The ensemble of objects – the old-fashioned velvet dress, the Asian china on the mantelpiece – embodies the principle that beauty is limited by neither time nor culture. But Solomon, true to her roots in narrative painting, alludes to another form of beauty: the moral beauty of a woman showing compassion for a wounded bird.

Rebecca Solomon

Rebecca Solomon (1832–1886)
The Wounded Dove
1866
Watercolour on paper
45.5 × 35.5 cm (17⅞ × 14 in.)
University of Wales, Aberystwyth

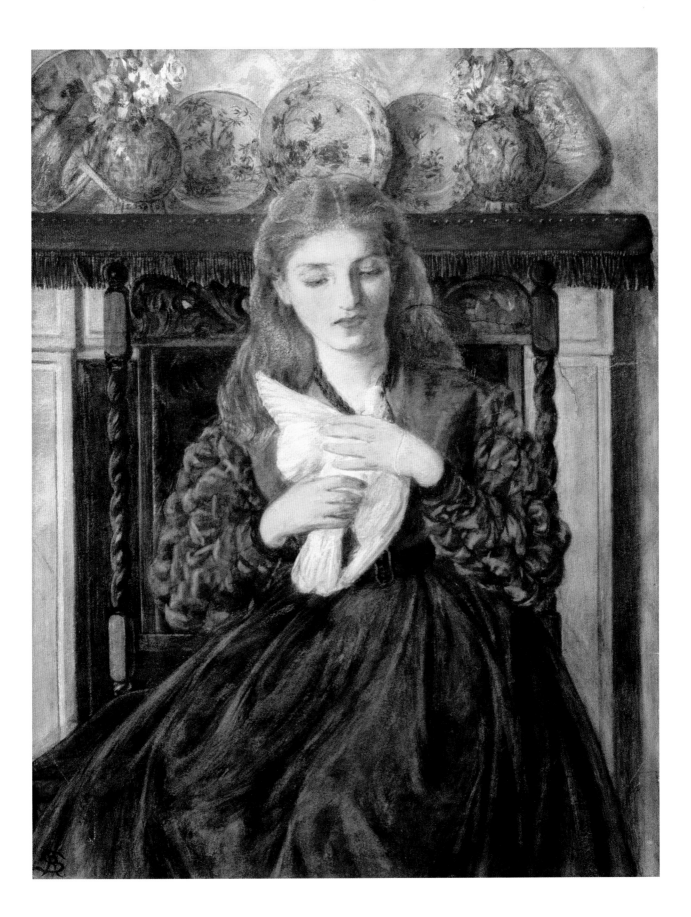

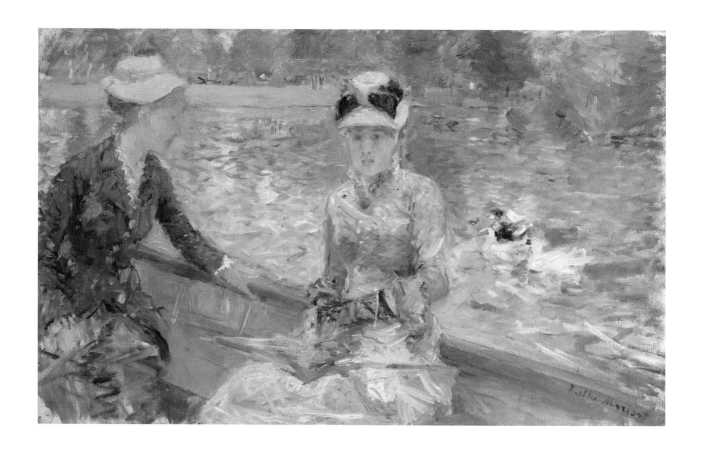

Conservative critic Albert Wolff described the core circle of a group of independent artists, exhibiting together for the second time in Paris in 1876, as 'five or six lunatics – among them a woman'.[11] The group had assembled for the first time in 1874 under the ambiguous name *Société anonyme des artistes, peintres, sculpteurs, graveurs, etc.*; they came to be known as the Impressionists, and the woman among Wolff's 'lunatics' was Berthe Morisot. Born into a wealthy upper-middle-class French family, Morisot had the advantage of education and art training, and her ambition led her to seek recognition beyond the status of talented amateur that was appropriate for a woman of her social standing. Between 1864 and 1873 her work was often accepted for exhibition at the official Salon, but her friendship with Édouard Manet led her to join the group of like-minded artists who championed alternative exhibitions and subjects taken from modern life.

With its sun-drenched luminosity and deft yet delicate brushstrokes, Morisot's *Summer's Day* (*Le Lac du bois de Boulogne*) displays her commitment to the innovative Impressionist approach of working quickly on an unprimed canvas in the open air. The image of two women enjoying a boating trip on a summer's day affirmed the notion that the simple pleasures of contemporary life – free from moral message or anecdotal detail – presented a worthwhile subject for a modern artist. The scene was, in fact, staged, and the women professional models, but Morisot captured the essence of the life she lived as a middle-class woman of comfortable means. Morisot exhibited in all but one of the eight Impressionist exhibitions; this work was featured in the fifth, held in 1880.[12] The critics often preferred her work to that of her male colleagues, giving her greater praise and suggesting that the Impressionist aesthetic was better suited to a woman's touch and talent than those of a man.

Berthe Morisot (1841–1895)
Summer's Day (*Le Lac du bois de Boulogne*)
c. 1879
Oil on canvas
45.7 × 75.2 cm (18 × 29⅝ in.)
The National Gallery, London

Berthe Morisot

In 1877 Edgar Degas invited Mary Cassatt to exhibit her work with
a group of independent artists in Paris. Her quest for art training had
taken her far from her home in Philadelphia. She had settled in the
French capital just three years earlier, and quickly gained acclaim for
paintings of sensuous bacchantes and handsome bullfighters. She also
attracted a regular portrait clientele, drawn from the circle of wealthy
American women who visited Paris not only for cultural enrichment
but also to purchase their wardrobes. Cassatt was on a steady path
to art-world success, but she turned away from her early triumphs to
exhibit her work with Degas's comrades at the fourth Impressionist
exhibition of 1879. This notorious group had attracted the ridicule
of the critics, but Cassatt enjoyed the challenge, as well as the freedom,
of being associated with the most progressive artists in Europe.

　　In common with the men of the Impressionist circle, Cassatt
painted subjects from modern life, but, as an unmarried American
woman, her perspective on Parisian life was strikingly different. Rather
than depicting the city's streets and cafes, Cassatt focused on her own
world – the parlour, the garden, the theatre – providing an unprecedented
look at the lives of middle-class women in nineteenth-century Paris. Here,
she takes us to a matinee at the Theatre Français, where a decorously
clad woman boldly surveys the crowd through opera glasses. In a witty
detail, Cassatt positions in the background a man, who leans out of
his box to focus his gaze on the painting's subject. However, Cassatt's
woman is not the hapless victim of unwanted attention; rather, she is an
active member of a lively audience, whose desire is to be seen as much
as to see a performance. Even among the Impressionists, Cassatt always
won critical attention, and although she was not the only woman to
exhibit with them (see page 31), she was the sole American.

Mary Cassatt

Mary Cassatt (1844–1926)
In the Loge
1878
Oil on canvas
81.3 × 66 cm (32 × 26 in.)
Museum of Fine Arts, Boston

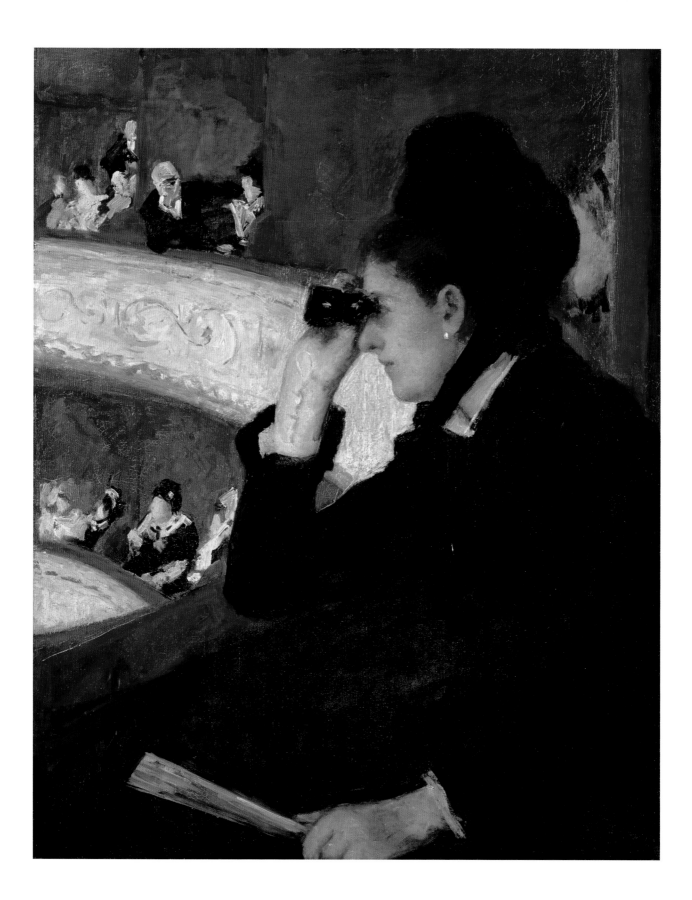

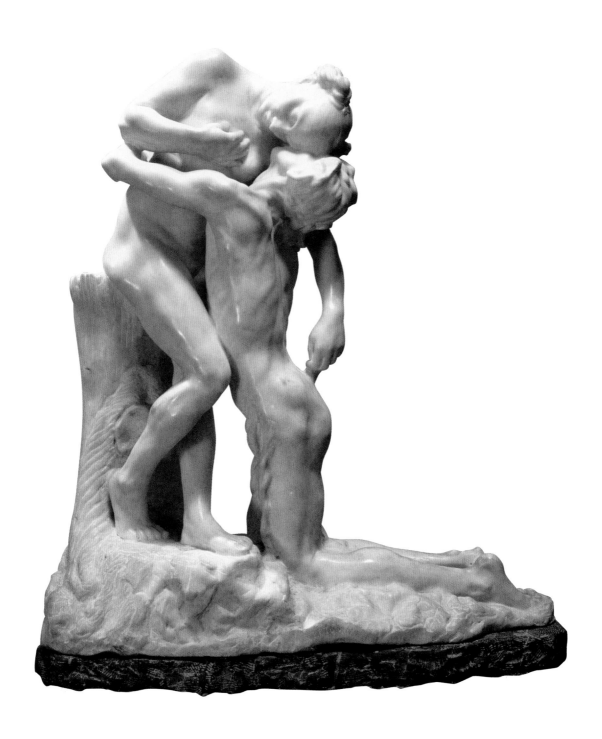

In 1888 Camille Claudel's plaster sculpture *Sakuntala* won an honourable mention at the Paris Salon. Claudel was known at the time for her association with Auguste Rodin (1840–1917), and the expressive physicality of her paired young lovers prompted comparisons with Rodin's recently completed *The Kiss* (1886). Claudel had met Rodin in 1882, when he served as a visiting instructor at an independent women's atelier.[13] Two years later she was working alongside his male assistants in his studio; one of them remembered her as Rodin's 'sagacious colleague', rather than just his pupil.[14] Determined to forge her own way in the art world, Claudel had hoped to translate *Sakuntala* into marble, but the government refused her request for funding, despite Rodin's outspoken advocacy.

Claudel was not able to carry out her plan until 1905, and by then she had asserted her independence – both personal and artistic – from the older sculptor. She changed little of her original concept, and her mastery of the medium gave the young, intertwined figures even greater urgency and passion. But the new title indicated a new subject. The original work featured King Dushyanta and Sakuntala, the star-crossed lovers of a Hindu tale written by the fifth-century poet Kālidāsa. A curse robs the prince of his memory, and his abandoned wife, Sakuntala, mourns until his miraculous recovery restores their love. The new subject was taken from Ovid's *Metamorphoses*. Vertumnus, the Roman god of seasonal change, adopted many disguises in his attempts to woo Pomona, but the strong-minded goddess of the orchards refused him until he appeared as a kindly old woman whom she could trust. Claudel never explained why she revised the content, but it is plausible that, once in command of her own career, she preferred to portray a goddess who made her own choices rather than a passive woman in thrall to destiny.

Camille Claudel (1864–1943)
Vertumnus and Pomona
1905
White marble on red marble base
91 × 80.6 × 41.8 cm (35⅞ × 31¾ × 16½ in.)
Musée Rodin, Paris

Camille Claudel

In April 1929 Wisconsin-born Georgia O'Keeffe made her first
visit to New Mexico. She had been invited to stay at the Taos home
of Mabel Dodge Luhan, a wealthy arts patron who had presided over
a community of artists and writers in the town since moving there in
1917. O'Keeffe's response to the starkly stunning landscape was
immediate. She obtained a driving licence and began to explore the
region by car, staying until the end of August. This was the longest
period of time that she and her husband, photographer and gallerist
Alfred Stieglitz (1864–1946), had spent apart since their marriage
in 1924. But in this new setting O'Keeffe discovered a different state
of mind, for, as she explained to a friend, art critic Henry McBride,
'I feel like myself – and I like it.'[15] In the following years she returned
to New Mexico as often as she could, resolving to make it her
permanent home some day.

O'Keeffe painted *Ram's Head, White Hollyhock-Hills* during her
second stay at Ghost Ranch, an 8500-hectare (21,000-acre) dude ranch
(a working ranch that accepts paying guests) in northern New Mexico.
She had been collecting and painting the bleached bones of cattle
and horses that she had found in the desert since 1931. But the hills
that anchor this composition were distinctive to her experience at
Ghost Ranch: she could see them from her room in the guest house.
Hollyhocks grew in the garden, and, in her mind, the startling
combination of the floating skull and flower converged with the view
in an aesthetic union. O'Keeffe disdained any symbolic reading of her
work, stating that she painted 'by selection, by elimination' to 'get at the
real meaning of things'.[16] In 1940, five years after painting *Ram's Head*,
she purchased Rancho de los Burros, a small cottage on Ghost Ranch
land; the solitude suited her, and after years of working with her
husband and within a circle of artists, she flourished on her own.[17]

Georgia O'Keeffe

Georgia O'Keeffe (1887–1986)
Ram's Head, White Hollyhock-Hills
1935
Oil on canvas
76.2 × 91.5 cm (30 × 36 in.)
Brooklyn Museum of Art, New York

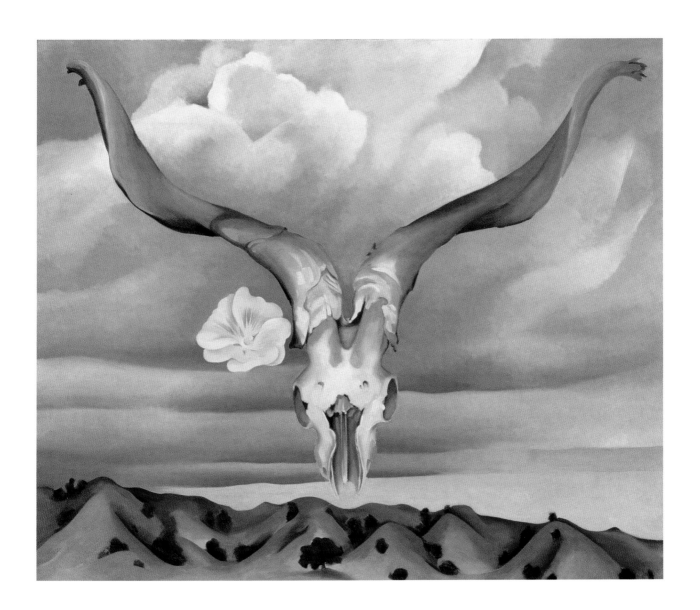

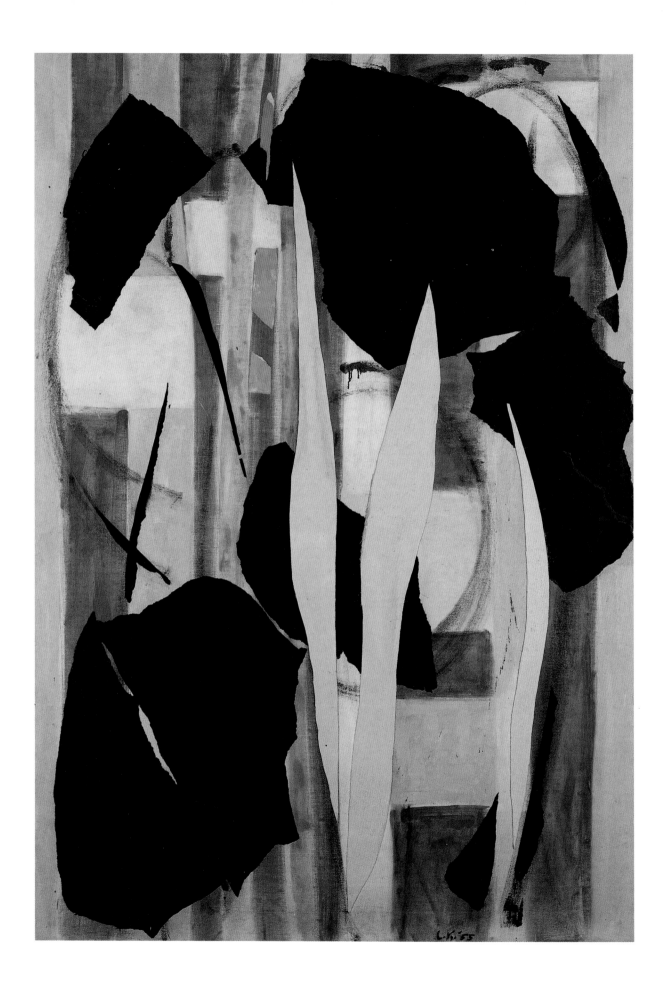

With characteristic candour, Lee Krasner
defined the issue that coloured the critical
reception of her work throughout her career:
'The fact that I was Mrs Jackson Pollock
complicated matters.'[18] She met Pollock,
a fellow American, in 1941, just as she
was abandoning the figurative elements in
her work. By the time they were married,
in 1945, she was a committed abstract painter,
and during Pollock's brief but spectacular
rise to fame she acted as his staunchest
advocate; after his death in 1956, she fiercely
protected his legacy. But, throughout her
life as an artist – from her student years to
her eventual recognition as a distinctive contributor to American
Abstract Expressionism – Krasner was just as protective of her own
artistic independence.

In 1949 *Artists: Man and Wife*, an exhibition of the work of
husband-and-wife artists held at the Sidney Janis Gallery in New York,
positioned Krasner in her husband's shadow. Critics repeatedly compared
the work of the featured spouses, asserting that the men were more
'adventurous' than the women.[19] Krasner then had her first solo show at
the Betty Parsons Gallery in New York in 1951. Over the next few years
her experiments with media led her to collage, and in 1955 she exhibited
a striking ensemble of these new works at Eleanor Ward's Stable Gallery
in New York. Using scraps from older works – including some of those
featured in her solo show of 1951 – Krasner boldly juxtaposed forms
on a painted field, as seen in the large-scale canvas *Milkweed*.

By turning to collage, Krasner created an expressive medium
exclusively her own. The strongly directional forms – thrusting
upwards – evoke the natural energy that Krasner always acknowledged
as an element in her work. *Milkweed* testified to Krasner's independence
of vision, and her exhibition of collage was the first step in her long and
often fraught struggle to be judged as an artist on her own terms.

Lee Krasner (1908–1984)
Milkweed
1955
Oil, paper and canvas on canvas
213.4 × 149.9 cm (84 × 59 in.)
Albright-Knox Art Gallery, Buffalo

Lee Krasner

In the art world, boundaries define media, refine technique and set standards for judgement. But boundaries also create difference – delineating the mainstream and the margins – and for women in the arts, difference has often turned boundaries into barriers. While many women have surmounted these obstacles by proving their worth in traditional modes of expression, others have seen a creative challenge in bending or blurring the boundaries, forcing critics and colleagues to set aside expectations and take a fresh look at their art.

Throughout the history of art, women have skilfully negotiated the imposed boundary between fine art and design. The colour theories that Sonia Delaunay formulated for her painting inspired her progressive textile and dress design (page 50); Isabelle de Borchgrave drew on her expertise in garment construction to bring figures from Renaissance paintings to life (page 62). Others have refused to be limited by conventions. Julia Margaret Cameron approached photography in the manner of an allegorical painter (page 48), while Maria Sibylla Merian made scientific history by seeking interesting subjects for her botanical studies (page 44).

Perhaps the most dangerous boundary a woman can blur is that of identity. Elizabeth Siddal was a model and a muse not only for the Pre-Raphaelites but also for her own work (page 46). When critics found Amrita Sher-Gil's foreign origins as fascinating as her painting, she cast herself as an 'exotic' in the mode of Gauguin (page 52). And Cindy Sherman subverts the separation between artist and subject by playing both roles in work that is simultaneously photography and performance (page 57). By blurring boundaries instead of breaking them, each of these artists asserts her own place in the art world, rather than have it defined by others.

Blurring Boundaries

Dressed in male clothing, Marietta Robusti accompanied her artist father as he visited his influential clientele in Venice. This deception afforded her social and professional experiences denied to other young women of her generation, and the training she received in her father's workshop surpassed that available to most aspiring male artists. Her father was Jacopo Robusti (1519–1594), known as Tintoretto, and by all accounts the famed painter doted on his talented daughter, who worked as diligently in the studio as her brothers Domenico and Marco.

The extent to which Robusti worked on her father's grand commissions is unknown. According to her first biographer, Carlo Ridolfi (1594–1658), she was a gifted portraitist. He cites two portraits, one of her grandfather Marco dei Vescovi and the other of Jacopo Strada, an antiquarian serving Maximilian II, Holy Roman Emperor. Scholars now also attribute to her hand this elegant self-portrait, which entered the collection of the Uffizi in the seventeenth century. In it, she presents herself as a musician; there is no sign of her vocation as a painter. Along with her gold-embellished lace gown, the harpsichord links her to the charms and talents more commonly ascribed to women. The musical score has been identified as the passionate love song 'Madonna per vio ardo', published in a book of madrigals by Philippe Verdelot in 1533.[1]

According to Ridolfi, Robusti received several invitations to work in prominent courts. However, her father was unwilling to let her leave, and arranged for her to be married to Marco Augusta, a Venetian goldsmith, 'so that she might always be nearby'.[2] Sadly, she died in childbirth at the age of thirty, and her short but brilliant life – as well as her father's deep and prolonged mourning – inspired such painters and writers as Léon Cogniet and George Sand to embellish her story.[3]

Marietta Robusti

Marietta Robusti (*c.* 1554–1590)
Self-Portrait
c. 1580
Oil on canvas
93.3 × 81.4 cm (36¾ × 32 in.)
Galleria degli Uffizi, Florence

Maria Sibylla Merian was thirteen when she saw her first silkworm. As an apprentice to her stepfather, the German flower painter Jacob Marrel (1614–1681), she observed the insect specimens that he used for his floral compositions. Marrel's brother was in the silk trade; perhaps it was his silkworms that she saw. Merian soon began to collect caterpillars and study their metamorphosis into butterflies. Her desire to 'sketch them from life in lifelike colours' dissolved the line between painting and natural science,[4] and Merian's exquisitely rendered illustrations in *Der Raupen wunderbare Verwandlung und sonderbare Blumennahrung* (Caterpillars: their wondrous transformation and curious floral alimentation; 1679) established her reputation as a pioneer of German entomology.

In 1691 Merian moved to Amsterdam, where she quickly made the acquaintance of other 'insect lovers', whose collections of specimens from the West Indies sparked her curiosity.[5] At the end of the decade she set off for Suriname, at that time a Dutch colony; her eldest daughter, Dorothea, was her sole companion.[6] Assisted by guides and servants supplied by local plantation owners, she sketched caterpillars and butterflies from life in the rainforest. The conditions were gruelling – and extraordinary for a woman – and in 1701 ill health forced her to return to Amsterdam.

With rest, Merian recovered her health and began work on her most ambitious project, sixty plates with commentaries for the publication *Metamorphosis insectorum Surinamensium* (1705). Working in watercolour on vellum, Merian mined her sketchbooks to create intriguing compositions in vivid natural tones. Here, she depicts the various life stages – caterpillar, pupa, butterfly – of *Philaethria dido* (scarce bamboo page butterfly) on a ripe pineapple. The examples of *Chilocorus cacti* (cactus ladybird) crawling on the pineapple's crown recall a long-standing convention of floral painting that she observed in her stepfather's studio: deploying a few unexpected insects to add a touch of whimsy.

Maria Sibylla Merian

Maria Sibylla Merian (1647–1717)
Philaethria dido and Chilocorus cacti,
drawing for plate 2 of *Metamorphosis insectorum Surinamensium*
Before 1705
Watercolour on vellum
Dimensions unknown
The Royal Collection, London

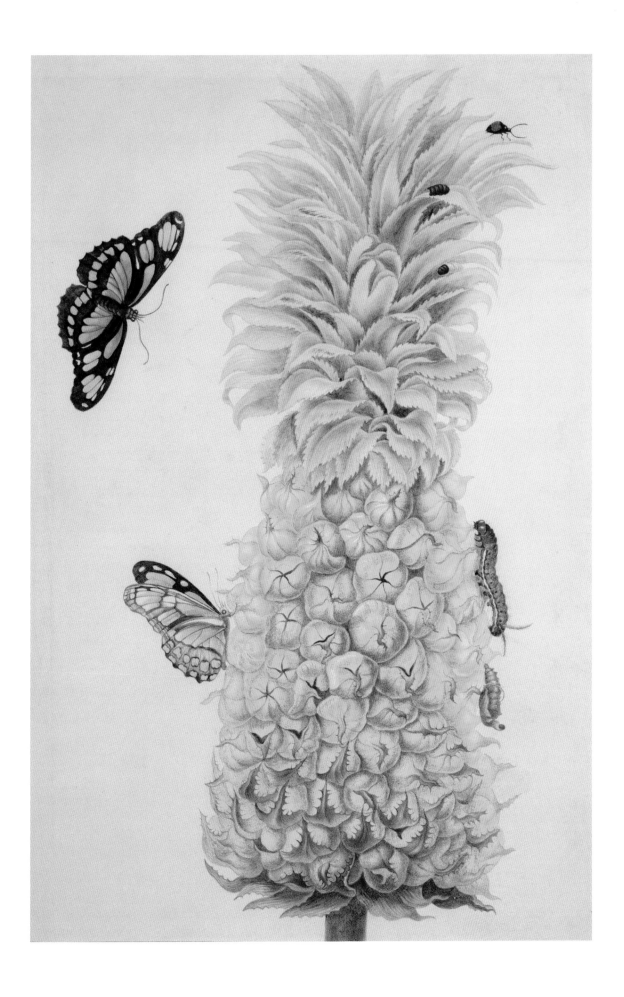

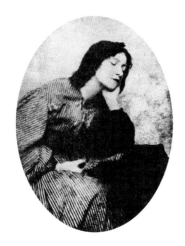

In 1854 the English artist and women's activist Barbara Leigh Smith wrote a letter to her friend Bessie Parkes to introduce Elizabeth Siddal as a kindred spirit: a woman with serious artistic aspirations. Smith warned her companion not to mention to anyone that Siddal had been a model, 'tho' only to 2 PRBs'.[7] Just five years earlier English artist Walter Deverell had spotted Siddal working in a milliner's shop and had asked her to pose for him. Through Deverell she met the artists of the Pre-Raphaelite Brotherhood, posing for more than two of them, most famously as Ophelia for John Everett Millais in 1852. By then she had forged a close relationship with Dante Gabriel Rossetti (1828–1882), becoming his muse as well as his exclusive model. Her ethereal image became so all-pervading – even other models came to resemble her – that his sister, Christina Rossetti, wrote that 'One face looks out from all his canvases.'[8]

But Siddal was not content just to model, and so turned her hand to drawing and painting. Rossetti encouraged her efforts, and, in 1854, they began to produce sketches to illustrate an anthology of Scottish ballads. Siddal developed some of her sketches into delicate watercolours, including *Sir Patrick Spens*, based on the ballad of the same name. The song tells of a doomed journey: the king of Scotland sends the nation's greatest hero to rescue his daughter held captive in Norway, but Spens does not return. Siddal portrays the ladies of the court huddled at the shore. The sole figure standing – pale-skinned, willowy, with flowing golden-red hair – resembles Rossetti's images of Siddal, and it is not clear whether Siddal intentionally painted herself into the scene or simply mirrored Rossetti's aesthetic. In common with the women in the ballad, who wait to see if they remain wives or have become widows, Siddal is caught between two roles: those of a model and an artist in her own right.

Elizabeth Siddal

Elizabeth Siddal (1829–1862)
Sir Patrick Spens
1856
Watercolour on paper
24.1 × 22.9 cm (9½ × 9 in.)
Tate Collection, London

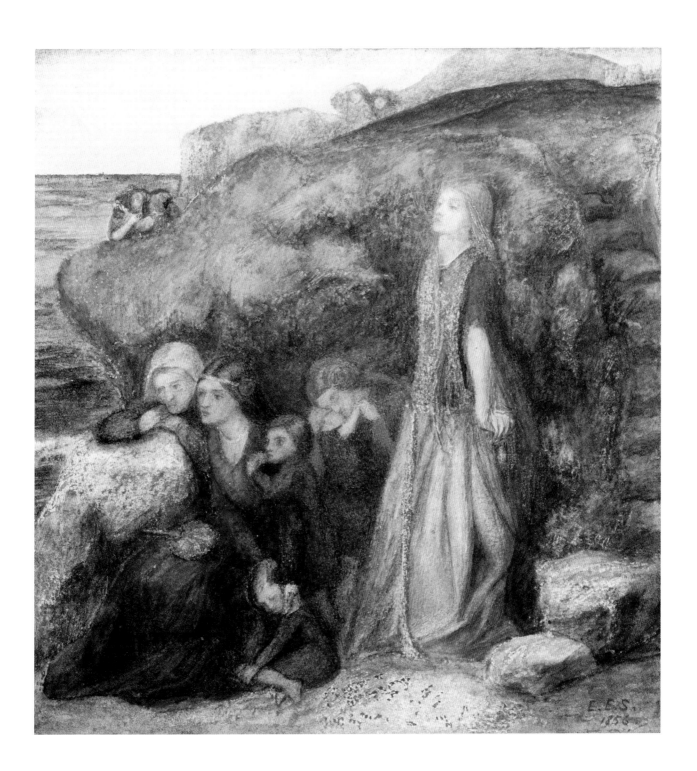

In December 1863 Julia Margaret Cameron received a sliding box camera from her daughter Julia with a note stating, 'It may amuse you, Mother, to try to photograph during your solitude at Freshwater.'[9] Julia's reference was to Cameron's residence in the quiet village of Freshwater on the Isle of Wight. A woman of great energy and boundless curiosity, Cameron had retired there in 1860 with her husband, Charles Hay Cameron, a former civil servant in the British judiciary in India. She now took up photography with her characteristic zeal and an inventive determination to explore the artistic potential of the new medium. She stated that her desire was to 'ennoble Photography' by approaching it as a 'High Art combining the real and the "Ideal"'.[10]

To that end, Cameron selected literary and allegorical subjects, and pressed her friends and family – as well as strangers – into posing for her in her 'Glass House', a conservatory that she had converted into a studio. For this photograph, she used a backdrop of branches, a diaphanous dress and a scattering of blossoms to transform her young model, Alice Liddell (1852–1934), into Pomona, the Roman goddess of the orchards. Unlike many of Cameron's models, Liddell had some experience before the camera.[11] A decade earlier she had posed for Charles Dodgson, a family friend who entertained her with his inventive tales, some of which he later published as *Alice's Adventures in Wonderland* (1865) under the pen name Lewis Carroll. He, too, explored the artistic possibilities of photography, but Cameron took her experimentation beyond the studio and into the darkroom. By painting directly on to her negatives and altering them with scratches prior to printing them, she sought to overcome the mechanical character of her medium with painterly effects, thus blurring the line between the representational nature of photography and the interpretational aspects of art.

Julia Margaret Cameron

Julia Margaret Cameron (1815–1879)
Pomona
1872
Albumen print
36.8 × 28.5 cm (14½ × 11¼ in.)
The Stapleton Collection, London

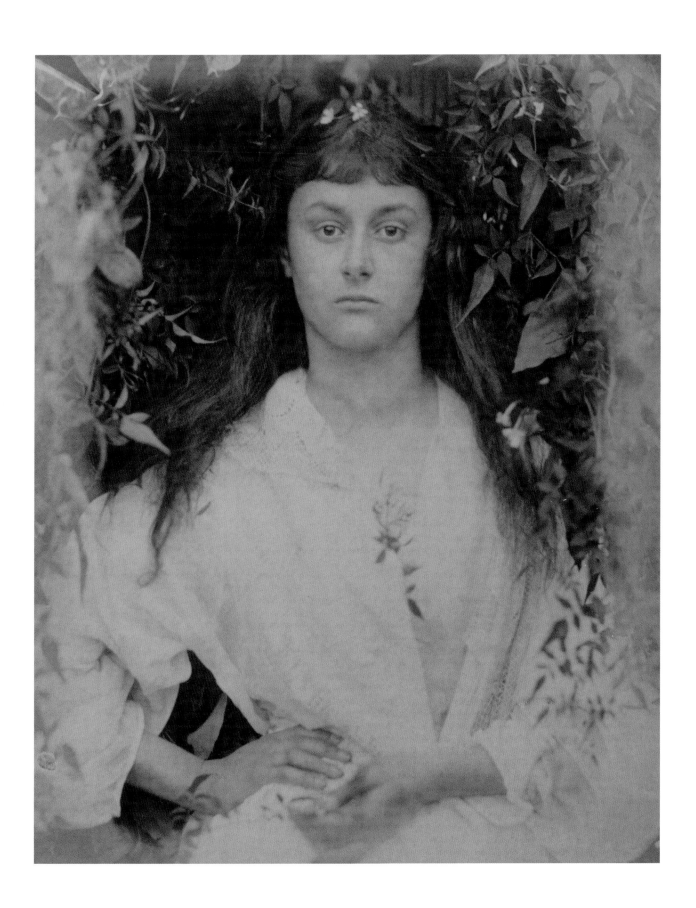

In March 1925 Sonia Delaunay registered the name 'Simultané' as a trademark and opened the Maison Delaunay in the Paris apartment she shared with her husband, artist Robert Delaunay (1885–1941). Earlier in the couple's marriage, in 1910, they had coined the term 'Simultaneity' to describe the theory behind their work, which sought to express the dynamism of modern life through the vivid, often jarring juxtaposition of colour in abstract form. Both explored the potential of Simultaneity in their painting, but in 1911 Delaunay applied the theory to making an appliqué quilt from scraps of fabric for their newborn son, Charles. Two years later she experimented with Simultaneity in garment design, crafting startlingly colourful clothes for herself and Robert. In an article for the *Mercure de France*, poet and critic Guillaume Apollinaire listed the hues in a single ensemble – violet, old rose, tangerine, blue, scarlet – and commented, 'Such variety has not gone unnoticed.'[12]

By the time Delaunay had created this bold chevron-print silk as part of her signature Simultané textile line, she was better known as a fabric and dress designer than as a painter. She worked with such prominent couturiers as Jacques Heim and Jacques Doucet, and enjoyed such celebrity clientele as film star Gloria Swanson and socialite Nancy Cunard. Her fabrics won wide acclaim in 1925 when they were featured in La Boutique Simultané, a shop-like exhibition space that she shared with Heim at the Exposition Internationale des Arts Décoratifs et Industriels Modernes in Paris. The critic for *L'Art Vivant* described Delaunay's display as 'the Kingdom of abstraction … the triumphant joy of colour'.[13] Delaunay never made a distinction between her painting and her design work; in fact, the scope of her work embodied the modernist objective to unify art and life through progressive design. But unlike the designs of many of her contemporaries, her innovative textiles and sleek styles not only advanced her avant-garde ideas but also proved a commercial success.

Sonia Delaunay

Sonia Delaunay (1885–1979)
Tissu simultané no. 204
1927
Block-printed silk crêpe de Chine
(printed by Ferret)
Les Arts Décoratifs, Paris

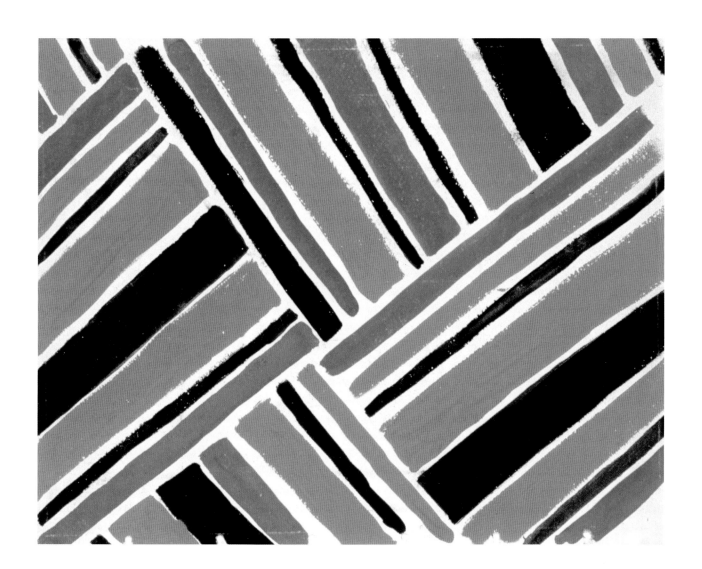

During her five-year stay in Paris (1929-34), Amrita Sher-Gil produced nineteen self-portraits. As a young art student it was only natural that she should explore her own image and identity; as a foreign woman of mixed race, however, Sher-Gil's investigations addressed larger issues than the journey from late adolescence to adulthood. Born in Budapest to a Hungarian mother and a Sikh father, Sher-Gil experienced a peripatetic childhood. When she was eight, the family moved to a suburb of Shimla in India; three years later, she and her sister, Indira, were taken by their mother to Italy to live with an Italian sculptor, their mother's new romantic companion. It was there that Sher-Gil, who had drawn since early childhood, decided to pursue her dream of becoming an artist and training at the École des Beaux-Arts in Paris.

Although Sher-Gil won critical acclaim for her work – as well as a gold medal at the Salon of 1933 – her multicultural heritage attracted just as much attention. It was the Jazz Age in France, and the press chose to focus on her 'exotic' image, portraying her as a 'little Hindu Princess' who 'conjures up the mysterious shores of the Ganges'.[14] Sher-Gil neither hid nor exploited her hybrid identity, and in portraying herself in the guise of one of Paul Gauguin's Tahitian women, she interrogated the idea of the exotic from a wholly new perspective.

The smoothly painted planes and solid masses of the body reveal that Sher-Gil easily mastered Gauguin's approach to the figure. But the full-featured face and thick, flowing hair mirror her own. The shadow of a man – perhaps Gauguin – looms behind her, and there are Japanese figures in the background, a reference to an earlier European fascination with an imagined East. With a determined expression, she dares the viewer to gaze at her through the false lens of exoticism. Having painted this decisive work, Sher-Gil chose to return to her father's homeland, stating that, while Europe belonged to other painters, 'India belongs to only me.'[15]

Amrita Sher-Gil

Amrita Sher-Gil (1913–1941)
Self-Portrait as a Tahitian
1934
Oil on canvas
90 × 56 cm (35⅜ × 22 in.)
Collection of Vivan and Navina Sundaram, Delhi

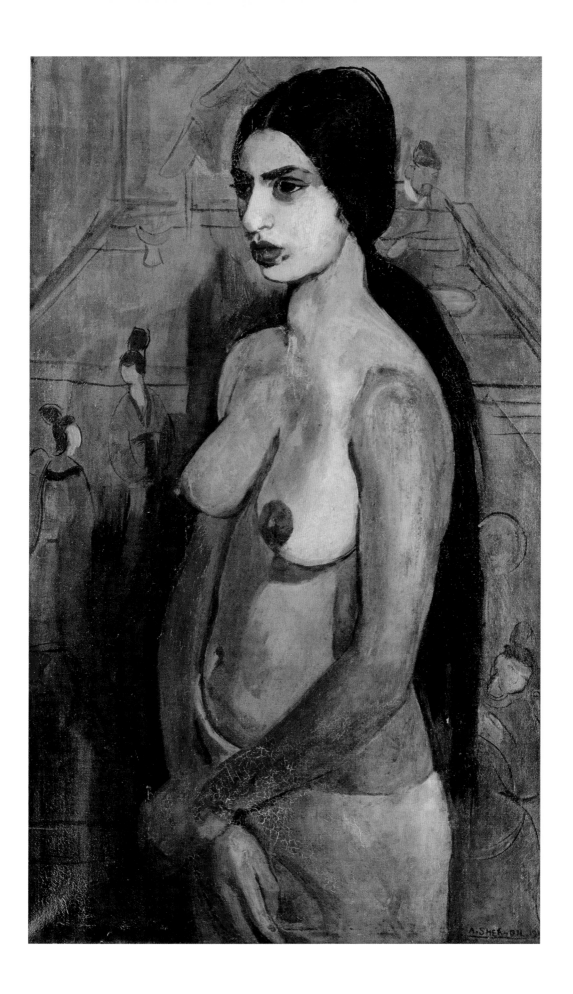

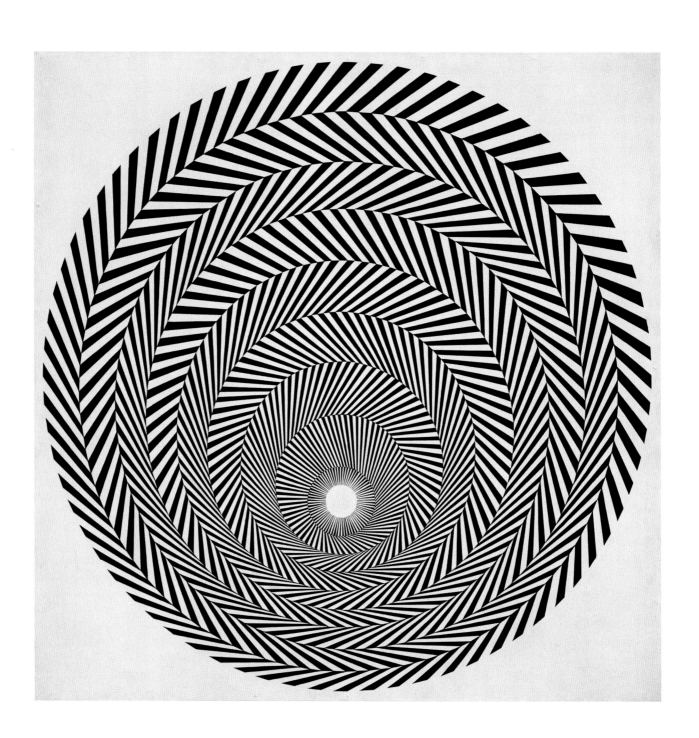

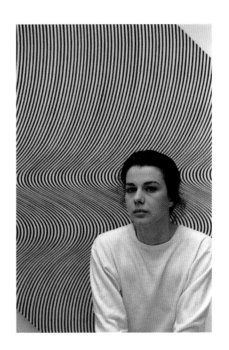

Before launching her career-long exploration of the effect of manipulated form on perception, English artist Bridget Riley produced a series of works in the style of French painter Georges Seurat (1859–1891). Between 1959 and 1960 she copied several of his canvases and created a pointillist vision of the Lincolnshire landscape. Riley felt a genuine affinity for Seurat's dynamic engagement with light and colour, and has cited the innovative artists of his circle, the Post-Impressionists, as 'her closest historical relatives'.[16] At first glance, Riley's rigorous, geometric patterning bears no aesthetic resemblance to Seurat's luminous views of landscape, but the deep connection Riley felt was anchored in method and objective rather than result. In common with Seurat, Riley wanted to invent a new visual language by testing the ways in which painted form stimulates ocular sensation.

With its pulsing, off-centre concentric circles orbiting an open void, Riley's *Blaze 4* became the icon of a new movement, dubbed 'Op Art', when it was featured in *The Responsive Eye*, a landmark exhibition organized by the Museum of Modern Art in New York in 1965. For Riley, however, the work was the culmination of several years of formal enquiry, during which she would select a shape and adjust and repeat it until she had unmasked all of its formal possibilities. Her resulting images often have a disorientating effect on the viewer's eye, creating the illusion of movement through the subtle variation of form. Riley has chafed at the assessment that her work defines a movement, and in contrast to those artists who readily embraced the idea of Op, Riley has never studied optics or physics; indeed, she has described her understanding of scientific theory as 'rudimentary'.[17] Riley's work is intensely personal: a deep, ongoing investigation into what form can do, conducted not according to theory but through trial and error.

Bridget Riley (born 1931)
Blaze 4
1964
Emulsion on hardboard
94.6 × 94.6 cm (37¼ × 37¼ in.)
Private collection

Bridget Riley

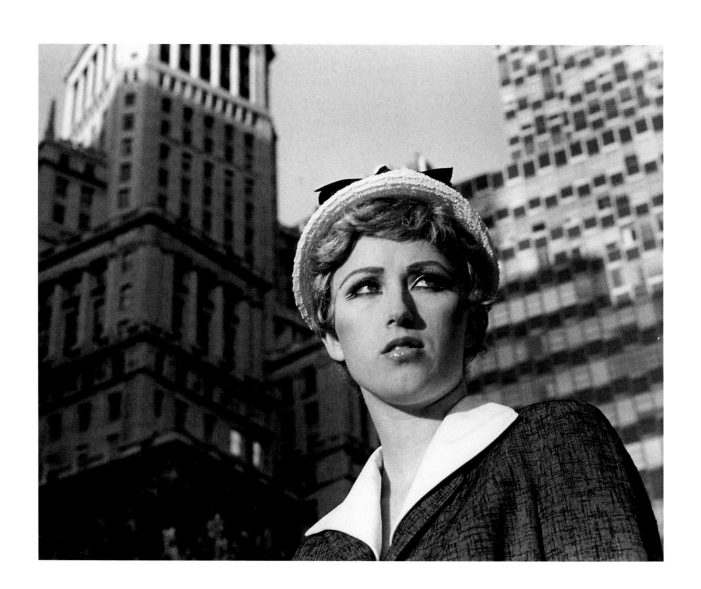

The ingénue has just arrived in the city. Her stylish suit, perky hat and neatly curled hair give her an air of professional confidence, but her wary expression betrays a sense of unease in her new and challenging environment. Cindy Sherman's photograph, taken from a low angle to catch the subject in the crowded streets of New York City, evokes a cinematic narrative in a single frame. We feel as if we have seen this film: a small-town girl moves to the big city seeking opportunity and romance, but her life takes an unexpected turn. But there is no film; there isn't even a story. And the ingénue is not an actress, but Sherman herself.

As a girl growing up in Long Island, Sherman loved to play dressing-up games. By the time she enrolled at Buffalo State College to study painting, she had developed her fascination with costume and disguise into a collection of wigs, second-hand clothing and make-up. In 1975, towards the end of her studies, she chose to focus on photography, and began photographing herself in character, as if her lone figure had stepped out of an extended tableau.

Untitled Film Still #21 is part of a series of sixty-nine black-and-white photographs, taken between 1977 and 1980, inspired by the film stills used to publicize Hollywood movies.[18] In each one Sherman adopts a distinctive yet familiar identity: the femme fatale, the exhausted housewife, the young woman, as seen here, on the brink of an unknown destiny. Relying on the language of popular film, as well as on costume and ambiguous gestures, Sherman evokes the essence of a story but refuses to tell the tale. Furthermore, for Sherman, the expressive invention is in the creation of the character, rather than the resulting photograph, blurring the line between performance and photography.

Cindy Sherman

Cindy Sherman (born 1954)
Untitled Film Still #21
1978
Gelatin silver print
19.1 × 24.1 cm (7½ × 9½ in.)
The Museum of Modern Art, New York

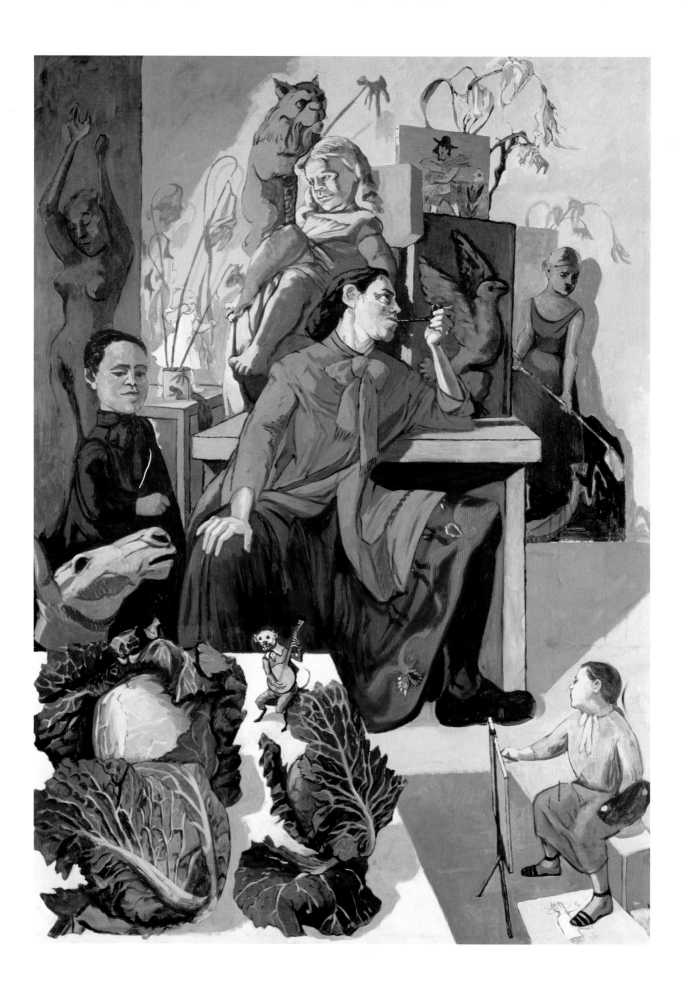

Ever since her days as an art student, first at St Julian's School in Carcavelos, Portugal (1945–51), and then at the Slade School of Fine Art in London (1952–56), Paula Rego has used her art to tell stories. In the manner of a traditional storyteller, she weaves her tales out of many strands: proverbs from her Portuguese homeland, operas and ballets, and fairy tales from such diverse sources as childhood memories and Walt Disney's cartoons. But Rego's images defy conventional notions of narrative or illustration. She works by instinct, allowing one form to lead to another, letting the images that she creates carry her through the story. Her automatist approach recalls the Surrealist practice of disassociating conscious behaviour from the creative process. Consequently, Rego's work transcends the traditional distinction between outward expression and inner life.

The Artist in Her Studio began with Rego drawing characters from *A Midsummer Night's Dream* by William Shakespeare. In the initial sketches, Bottom, his head transformed into that of a donkey, embraces Queen Titania while other figures, including the bear referred to in *Pyramus and Thisbe*, the play being rehearsed by Bottom and his fellow actors, circle around them. But, in the course of her sketching, Rego turned the enchanted wood into an ancient sculptor's studio, and then transformed the male sculptor into a woman.[19] The resulting painting portrays the woman in various guises: as a little girl in an artist's smock, as a sculpted figure of a child in a chair, and, in the bottom right-hand corner, as a tiny artist capturing the scene on her canvas. At the centre is a bold woman in a lavender smock and an embroidered peasant skirt. Rego refutes the suggestion that this is a self-portrait – she based the figure on Lila Nunes, one of her regular models – but the pose, the pipe and the farmer's clogs directly reference the self-portraits of nineteenth-century French artist Gustave Courbet. Rego's creative convergence of images enchants and ignites the imagination, but resists an easy explanation.

Paula Rego

Paula Rego (born 1935)
The Artist in Her Studio
1993
Acrylic on paper laid on canvas
180 × 130 cm (70⅞ × 51⅛ in.)
Leeds Art Gallery

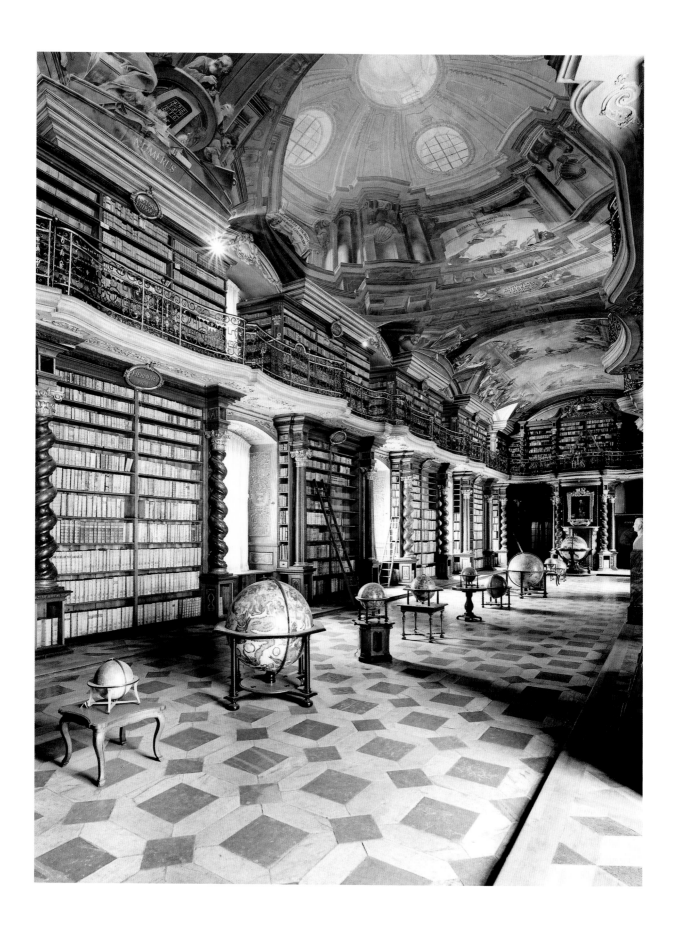

Spaces that house collected objects fascinate Candida Höfer, a photographer born in Eberswalde near Berlin. She is drawn to libraries and museums, and her large-format, richly toned photographs feature interiors in which people come to 'share or receive knowledge, where you can relax and recover'.[20] But, as seen in her photograph of the vast, lavish interior of the Baroque Library Hall in Prague, built in 1722 and now part of the National Library of the Czech Republic, she captures these chambers of cultural activity and intellectual exchange when they are empty. Although neither men nor women inhabit the space, the interior bears profound witness to human activity. Within this beautifully appointed chamber, there are books to be opened, paintings to view, globes to be studied and spun, all in stasis and waiting for a curious visitor to enter the hall and animate their vitality.

Höfer began her career as a photojournalist, shooting portraits for newspapers. In 1973 she enrolled in the Kunstakademie Düsseldorf, where she studied photography under Bernd and Hilla Becher. Along with other Becher students, including Thomas Struth, Andreas Gursky and Thomas Ruff – a group now referred to as the Photo-Conceptualists of Düsseldorf – Höfer explored the potential of new colour processes and large-scale printing. Both the magnitude and the subtly burnished tones of her photographs suggest the aesthetic qualities of painting. But it is the angle of her camera, seeming to hover on the chamber's threshold as if hesitating before entering the space, that preserves the accidents of light and protects the aura of silence in empty spaces. Beyond her stated interest in those 'special objects' that people assemble in designated spaces, Höfer refrains from entering a debate about the nature of her medium. She wryly explains that she believes in the separation of 'labour' in art: 'I just do the images. Others do the interpretations.'[21]

Candida Höfer (born 1944)
National Library of the Czech Republic, Prague II
2005
Chromogenic print
188.5 × 154.6 cm (74¼ × 60⅞ in.)
Detroit Institute of Arts

Candida Höfer

During a visit to the Galleria degli Uffizi in Florence, Isabelle de Borchgrave imagined a delightful scenario: wouldn't it be magical if the figures in Renaissance paintings came to life, stepped out of their framed canvases and posed as three-dimensional figures in the galleries?[22] Borchgrave knew exactly how to transform her flight of fancy into reality. For more than a decade she had been making garments out of paper, re-creating historic costumes and couture designs in the form of life-size, meticulously detailed sculptures that made her modest material appear as luxurious as the softest silk or the plushest velvet.

After completing her studies at the Centre des Art Décoratifs and the Académie Royale des Beaux-Arts, both in her home town of Brussels, Borchgrave enjoyed a highly successful career as a decorative designer, first gaining notice in the late 1960s for hand-painted fabrics. In 1994 a visit to the Costume Institute at the Metropolitan Museum of Art in New York inspired her to return to fine art, with garments as her subject and paper as her medium. She manipulated paper so that, in form and flow, it resembled cloth; her earliest creations were left white, but over the years she incorporated *trompe l'œil* to simulate delicate embroidery and complex jacquard, as well as lace, ribbons and other ornaments.

In *Flore*, part of a series that celebrates the patronage of the Medici family in Florence, Borchgrave brings Botticelli's goddess of spring to life. The diaphanous white dress, embellished with painted and sculpted flowers, seems to flutter on the gusts of a warm breeze. Borchgrave captures the painting's message of transformation by using colour and the suggestion of movement to evoke the sensual but fleeting delights of the season. Through her medium she shares her fantasy of bringing figures out of their frames, 'just for the pleasure of walking around them'.[23]

Isabelle de Borchgrave

Isabelle de Borchgrave (born 1946)
Flore
2007
From the series *Splendour of the Medici*
Paper costume inspired by the allegorical figure of Flora in Sandro Botticelli's painting *Primavera* (c. 1478)
189 × 64 × 68 cm (74⅜ × 25¼ × 26¾ in.)
Collection of the artist

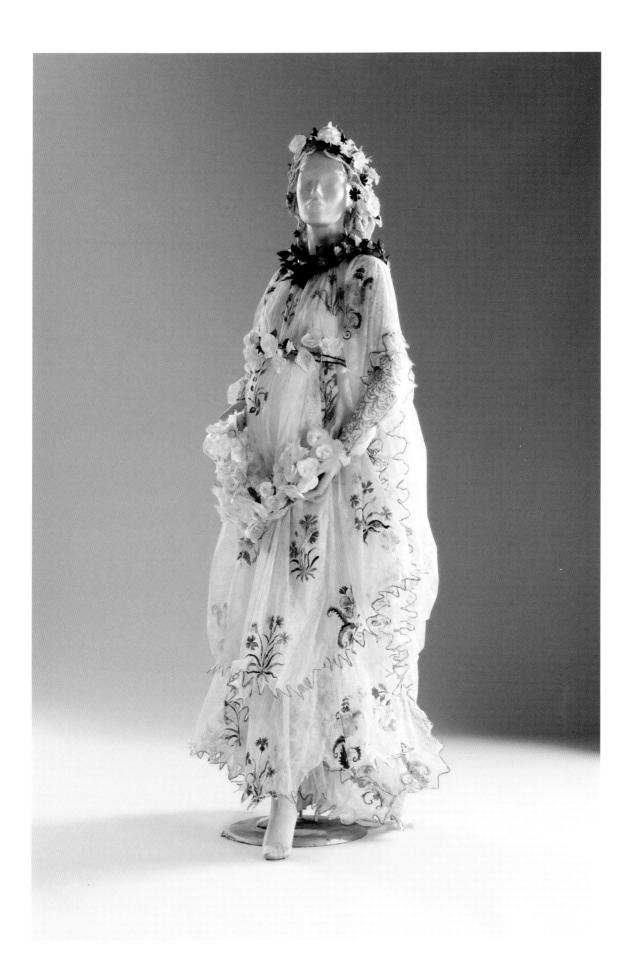

Few images are as compelling as those of the human body. Throughout history, artists have explored the body's potential to incarnate meaning, to arouse empathy and emotion, and to portray abstract and physical ideals. Study of the human form has long been deemed an essential part of an artist's education. But until the twentieth century – on the pretext of protecting the morality of the 'fair sex' – women's access to life classes and nude models was limited. How, then, did female artists circumvent this prohibition, and, more importantly, what dangers surfaced when women began to look at bodies?

It is not possible to document where and when a woman artist first worked with a nude model, and it is easy to imagine that, throughout the ages, female apprentices and assistants have watched their male masters work from life. But the earliest known nude attributed to a woman suggests that her source was classical sculpture rather than a live figure (page 66). In the late nineteenth century, women intent on learning to draw from life could choose from several academies in Paris (pages 68 and 70). However, although the life studios were separated by gender, the teachers were always male, and the opportunities hardly equal.

Such aspiring artists as Gwen John and Suzanne Valadon (pages 73 and 74, respectively) subverted the common gender dynamic of male artist and female model by posing nude to learn technique as well as earn a living. And, as women took control of the subject, they transformed the limited notion of the nude as an ideal or an icon (pages 76, 79 and 80). By looking at bodies from their own perspective, and by valuing experience over objectification, women unleashed a new potential in an age-old form.

Looking at Bodies

The conventional means by which to study the nude – life models and anatomical research – were not available to women of Lavinia Fontana's era. But, as the daughter of Prospero Fontana (1512–1597), a well-established painter whose practice included altarpieces and portraits of the esteemed citizens of Bologna, she may have learned to paint the human body by observing casts, engravings or even her father at work in his studio. From her adolescence until her father's death, Fontana served as his assistant, and by the time of her marriage to Gian Paolo Zappi in 1577, she was so accomplished that Zappi put aside his own painting career to act as her business manager.

In common with her father, Fontana painted portraits and altarpieces, and in 1585 she produced what is believed to be her first work featuring a full-length nude, *Venus and Cupid*. The circumstances surrounding the work are unknown, but the figure of Venus resembles antique statuary. Her depiction of the goddess Minerva has the same monumental proportions – sloped shoulders, long torso and short legs – associated with ideal classical beauty, suggesting that she based her form on admired works of art rather than a live model.

Fontana painted *Minerva Dressing* towards the end of her life, after a decade of successful work in Rome. It is thought that the acclaim she earned for painting an altarpiece for a chapel in the church of Santa Sabina in Rome encouraged her to move there in 1604.[1] Her primary Roman patron, Camillo Borghese, was the former papal legate to Bologna; in 1605 he became Pope Paul V, and Fontana painted *Minerva Dressing* for his nephew and adopted son, Cardinal Scipione Borghese. While the graceful pose of the goddess would have appealed to the renowned collector for its evocation of classical beauty, the fact that the nude was painted by a woman would have marked the work as a rare addition to his collection.

Lavinia Fontana

Lavinia Fontana (1552–1614)
Minerva Dressing
1613
Oil on canvas
260 × 190 cm (102⅜ × 74¾ in.)
Galleria Borghese, Rome

In nineteenth-century Paris, female artists who wished to study the human figure had few options. They were banned from life classes at the École des Beaux-Arts. A woman assisting in a studio might have been able to observe a modelling session, but the conservative atmosphere of the day discouraged women from watching other women pose in the presence of a man. Some women artists posed for one another, but that, too, was regarded as suspect. By the 1860s, however, some of the more forward-thinking professors from the École opened their studios to women for exclusive, single-sex classes.

Eva Gonzalès spent a year in the atelier for women run by the society portrait painter Charles Chaplin (1825–1891). This oil sketch of a model might have been drawn during the time she spent under his tutelage (1866–67). As the professor, Chaplin would have set the model's pose and corrected the students' sketches. Female models would be either lightly draped or nude, but male models would have worn some type of covering over their groin. Chaplin earned a reputation for impeccable propriety; the guarantee that only women would be present reassured 'careful mothers' that their daughters would not be exposed to 'any complications arising between the sexes'.[2]

It is not known why Gonzalès spent only a year in Chaplin's studio. In 1869 she met Édouard Manet, and soon became his model and then his pupil. In his studio she cultivated her interest in scenes from contemporary life. Whether she had the opportunity to continue her life studies cannot be established, but her paintings always featured the human form. And it is certain that she valued the brief time she had spent in Chaplin's atelier: when she debuted at the official Salon in 1870, she identified herself in the catalogue as his student.

Eva Gonzalès

Eva Gonzalès (1849–1883)
Le Chignon
c. 1865–70
Oil on canvas
51 × 40 cm (20⅛ × 15¾ in.)
Private collection

A peripatetic childhood – moving with her mother's family from their native Ukraine to such European cultural capitals as Vienna, Baden-Baden and Nice – transformed the precocious Mariya Bashkirtseva into a polymath. By the time she was fourteen, she was not only fluent in several languages but also an accomplished singer and pianist, and she began to keep a detailed diary. In 1877 she convinced her family to move from Nice to Paris, where she planned to study the visual arts. They arrived in mid-September, and on 2 October she attended her first class at the Académie Julian.

The academy, founded in 1868 by Rodolphe Julian (1839–1907), offered two separate programmes of study: one to help men prepare for the entrance examination at the École des Beaux-Arts, and one for women seeking rigorous art training.[3] Men and women worked in separate studios, and although Julian firmly believed that some of his female pupils 'give as much promise as the men', Bashkirtseva readily recognized differences between the programmes.[4] Although both roughly followed the same curriculum, the women's studio had limited access to life models. Once established at the academy, Bashkirtseva expressed her frustration, and in 1880, as a result of a petition she had circulated among her classmates, Julian changed his policy, scheduling for his female pupils full-day sessions with the same experienced life models as used by the men.[5]

Bashkirtseva's painting of a life class in the women's studio presents a lively and focused group of female students observing a young male model holding a classic academy pose. Classes may have been equal in terms of content, but they were still divided by gender: the youth on the platform is the only male in the room, and his nudity is partial; he would have been fully undraped in the male studio. The only other men permitted in the women's studio during a life class were the professors (who were exclusively male).

Mariya Bashkirtseva

Mariya Bashkirtseva (1858–1884)
In the Académie Julian
1881
Oil on canvas
154 × 188 cm (60⅝ × 74 in.)
Dnipropetrovsk State Art Museum, Ukraine

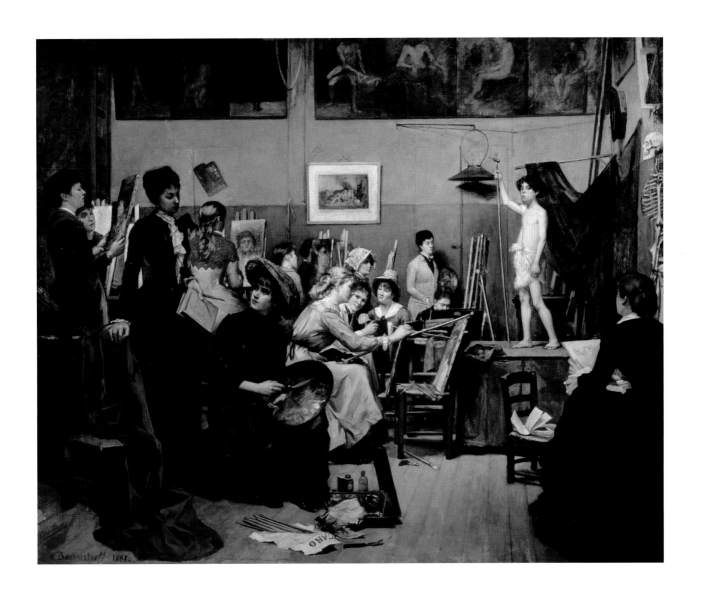

During her first extended stay in Paris (1904–11), Welsh artist Gwen John investigated figure drawing from both sides of the easel. She had come from London to immerse herself in the latest developments in modern art, and in order to supplement her meagre finances she offered her services as a life model, posing mostly in private for American and British women in similar circumstances. She also modelled for Auguste Rodin, most notably for the figure in *Muse, Monument to James McNeill Whistler* (after 1905).[6]

At the same time, the nude intrigued John as a subject in her own work. She frequented the life-drawing studio at the Académie Colarossi, and in about 1909 posed for herself in front of a mirror in her room for a series of five full-length drawings. In each, she depicts a figure holding a sketchbook, but she either leaves out or generalizes the facial features, as if to underscore the nature of the work as figure drawing rather than self-portrait.

But there is nothing neutral about the distinctive appearance of the model in *Girl with Bare Shoulders*. She can be easily identified as Fenella Lovell, a professional model who had also posed for John's brother, Augustus. Although John described Lovell as a 'horrid character', she painted her twice – once partially clothed, here, and once nude – in almost the same position.[7] The dress worn by Lovell in *Girl with Bare Shoulders* is slim and made of a light fabric, revealing her slender proportions and leaving her arms, as well as her shoulders, bare. Both conceptually and emotionally, John exposes her model; Lovell seems to flinch under her gaze. Years later, a critic cited John's power to convey an 'almost painful intimacy' in her paintings of women.[8] Perhaps this was a reflection of her own experience of being subjected to an artist's unrelenting scrutiny.

This portrait of Gwen John by the English painter Ambrose McEvoy (1878–1927) was probably painted some time between 1898 and 1900, when the two artists were romantically attached.

Gwen John (1876–1939)
Girl with Bare Shoulders
c. 1909–10
Oil on canvas
43.4 × 26 cm (17⅛ × 10¼ in.)
The Museum of Modern Art, New York

Gwen John

Suzanne Valadon pictured with her son, Maurice (1883–1955), in about 1895. He also pursued a career as a painter, adopting the surname of a family friend to become Maurice Utrillo.

The subject of French artist Suzanne Valadon's *Reclining Nude* has a venerable heritage. From the visions of Venus by such Renaissance masters as Giorgione and Titian to the odalisques imagined by such Romantic and modern masters as Ingres and Matisse, painters have represented beautiful women, disrobed or lightly veiled, reposing on a chaise longue, as a passive yet evocative object for the viewer's gaze. Historically, the interpretation of the reclining nude – whether for male or female viewers – has been from a male point of view. When Valadon embraced the subject, she shifted the perspective with disquieting results.

Valadon could empathize with a woman exposing her body to an artist's scrutiny. For more than a decade, from about 1880 to 1893, she earned her living as an artist's model, posing for such prominent painters as Pierre Puvis de Chavannes, Pierre-Auguste Renoir and Henri de Toulouse-Lautrec. Keenly observant, she acquired techniques as she posed, and her early drawings, dating from this same period, reflect the influences of these artists. By the mid-1890s, when she turned her full attention to her own career, the nude played an important role in her repertoire.

Valadon's nudes often took unorthodox forms: she paired them with dressed figures, placed them in unlikely settings, and, on occasion, subverted expectations and painted men. And although *Reclining Nude* echoes the position of countless beauties reposing on couches throughout the centuries, Valadon challenges convention with subtle details. The voluptuous, blonde woman is beautiful, but there is nothing placid about her demeanour. She is clearly uncomfortable; the divan is too small for her. Her crossed legs angle her body away from the viewer in a gesture of resistance. And her gaze – while inscrutable – is not impassive. In *Reclining Nude*, Valadon empowers the woman to gaze back, and, in doing so, transforms the subject from an idealized icon into a credible image of a woman.

Suzanne Valadon

Suzanne Valadon (1865–1938)
Reclining Nude
1928
Oil on canvas
60 × 80.6 cm (23⅝ × 31¾ in.)
The Metropolitan Museum of Art,
New York

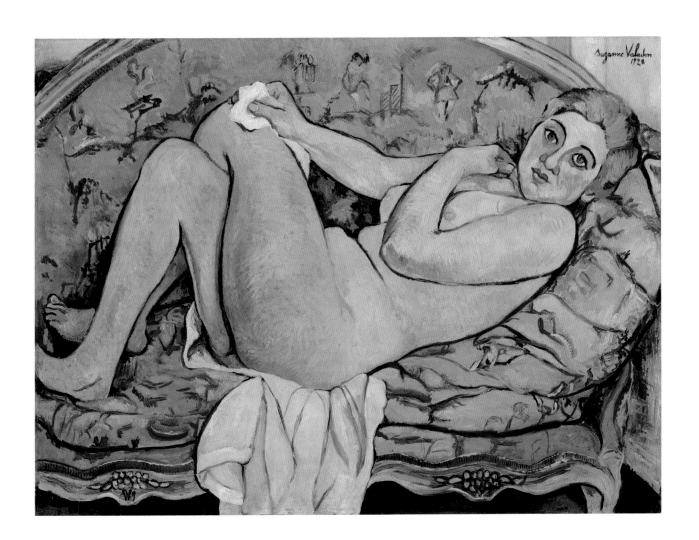

Rebecca Horn's studies at the Hochschule für Bildende Künst in Hamburg (1964–70) were put on hold in 1967. The German artist had been crafting sculptures from fibreglass without wearing a protective mask, and in order to recover from the resulting lung poisoning, she spent a year in a sanatorium. As her health improved she resumed her work; and while still confined to bed, she began to sew forms out of cotton and gauze bandages. The months of convalescence had heightened her sensory awareness, and she began to think differently about the place of her body in space. Recalling her confinement, Horn says that 'All of my performances come out of my experiences at this time.'[9] In 1968, having made a full recovery, she created *Arm Extensions*, the first of a series of body sculptures/performances exploring through altered proportions the relationship between the human body and its environment.

Arm Extensions both restricts and extends the body. The vivid red bandages that wrap the torso and crisscross the hips and legs turn the wearer's body into an immobile pillar. At the same time, thick columnar prosthetics encase and lengthen the wearer's arms. Horn, seen here in the sculpture, explains that, after a while, the work alters the wearer's perceptions, such that they begin to feel as though their arms have become 'isolating columns' that remain fixed to the body but grow into the floor.[10] In the years that followed this work, Horn continued to explore how extensions to the body alter an individual's perception of physical existence, creating gloves with elongated fingers for touching distant objects, a unicorn head to exaggerate height and feathered wings to shield the eyes or engulf the body. While such extensions transform the body in spectacular ways, Horn believes the importance of the sculpture lies in wearing it, rather than merely seeing it. Through her extensions, Horn shifts the nature of the body from object to experience.

Rebecca Horn

Rebecca Horn (born 1944)
Arm Extensions
1968
Fabric, wood and metal
123 × 60 × 51 cm (48⅜ × 23⅝ × 20⅛),
when displayed
Tate Collection, London

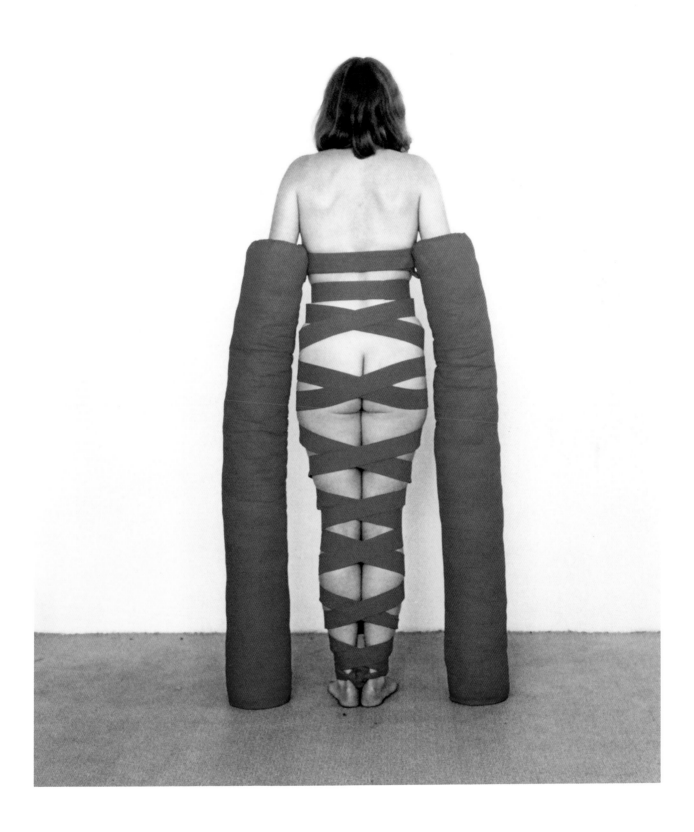

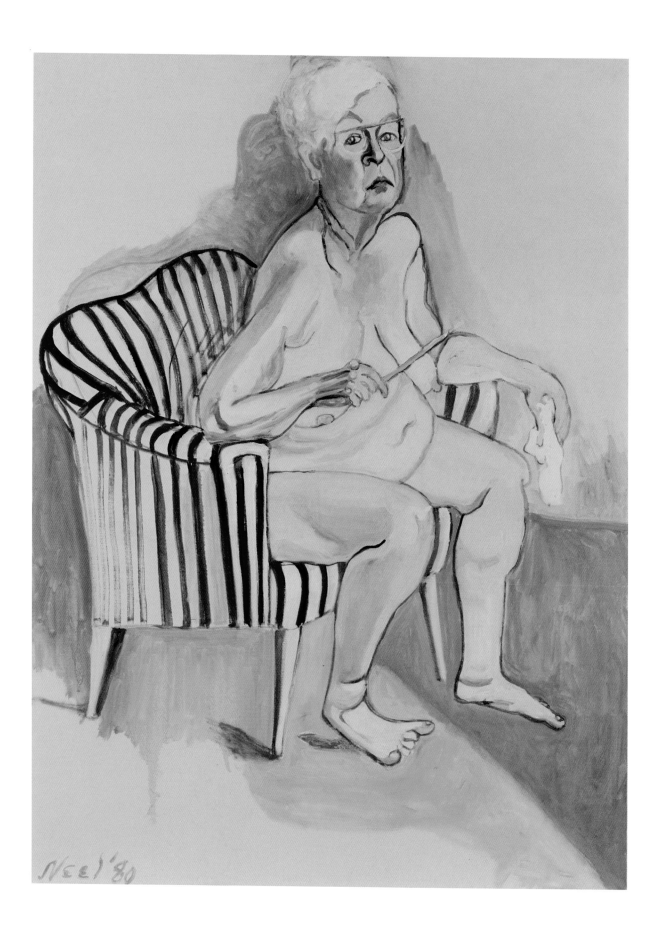

When American artist Alice Neel invited someone to sit for a portrait, she treated them like a guest. She used the living room in her apartment as her studio, and often served lunch or tea and biscuits before the sessions began. She posed her subjects on a comfortable couch or chair, and as she took her own position behind her easel, she kept up the conversation – often telling suggestive stories – believing that an intimate atmosphere encouraged trust and enabled the sitter to relax into a 'characteristic pose' and reveal 'what the world has done to them'.[11]

Neel's art training at the Philadelphia School of Design for Women (1921–25) did not include life classes, so when she began to paint nudes in the late 1920s, she developed her own approach inspired by the brutal honesty of German expressionism. She depicted what she saw, never idealizing her subjects, and employed creative distortion to convey their individuality. Sitters recall that Neel always asked them to take off their clothes, and many did, including the famously shy Andy Warhol, who, for a portrait painted by Neel in 1970, removed his shirt to expose the scars from his gunshot wounds.[12]

Neel was seventy-five when she began this self-portrait; she found it difficult to work on and put it to one side, but finished it five years later. Strong blue outlines emphasize the heavy stomach and sagging breasts of her once shapely figure, but her head is held proud, and her likeness captures successfully the unflinching gaze with which she observed her sitters. She had once joked to her artist colleague Benny Andrews that 'I am cursed to be in this Mother Hubbard body. I am a real sexy person.'[13] But, in her art, physical evidence was the ultimate truth, and she conveyed what the world had done to her in the contours of her own ageing body.

Alice Neel (1900–1984)
Self-Portrait
1980
Oil on canvas
135.3 × 101 cm (53¼ × 39¾ in.)
National Portrait Gallery, Smithsonian
Institution, Washington, D.C.

Alice Neel

The human body is Jenny Saville's subject, and she works on a grand scale, in terms of both the size of her canvas and the magnitude of her models. The English painter and photographer employs poses that twist and stretch the body into awkward positions, and she foreshortens and crops her figures so that they crowd the canvas from edge to edge, making it appear as though her nudes are struggling against their claustrophobic confinement. Saville never recoils from corporeal reality; the weight of sagging muscle and the discoloration of bruised and damaged skin fascinate her. Her nudes are never idealized, and she rejects the traditional concept of female physical beauty as a 'male fantasy' of the female body. Her paintings assert her belief that 'what women think is beautiful can be different'.[14]

In *Shift*, Saville explores the variability of form; the female figures range from full-bodied and heavy-breasted to taut and lean. But the arrangement of the six figures – side by side, head to toe – transforms their bodies into a kaleidoscopic pattern of subtle and contrasting colour. While Saville is committed to portraying the reality of human form, it is aesthetic transformation that fascinates her. She does not paint from life, explaining that she is not seeking an 'illusion' of the female body: 'I am more interested in painting areas of flesh.'[15] Rather, she works from photographs that she has taken of herself and her models, selecting those images that, through their colour, texture, mass and tonal variation, reveal to her the full painterly potential of her subject. It is through this act of expressive painting that Saville elevates the material reality of the human body into a sensuous display of nuanced colour and shimmering surface; her handling of her medium, rather than her observation or interpretation, transforms flesh into art.

Jenny Saville

Jenny Saville (born 1970)
Shift
1996–97
Oil on canvas
330 × 330 cm (129⅞ × 129⅞ in.)
Private collection, courtesy of
Gagosian Gallery

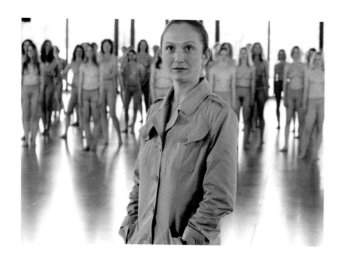

In an interview conducted in 2003, Italian artist Vanessa Beecroft described the women in her performances as 'material'. During a performance, which may last for hours, her models are permitted to shift position, stretch and even rest on the floor, for, as Beecroft explains, material is 'subject to its own changes'. She controls her work through the initial selection of models, who are then costumed and choreographed so that they begin the performance as 'a material in an almost pure state'.[16]

Beecroft began staging performances in 1994, titling each one with her initials and a number representing its position in her œuvre. Her performances are conceived for their settings; for the three-hour *VB62*, held in an unfinished sixteenth-century Sicilian church, Beecroft took her inspiration from the sculptural traditions of Palermo, ranging from the serenely elegant busts of the late fifteenth-century sculptor Francesco Laurana to the innovative use of stucco by the late Baroque sculptor Giacomo Serpotta. Her 'material' consisted of thirteen figures cast from her own body and those of her step-sister and selected friends, and twenty-seven hired models, who were nude except for chalk-white body paint. All were positioned on plinths, platforms or the floor, in attitudes that evoked classical sculpture.

The slender proportions of Beecroft's models, as well as their racial and ethnic homogeneity, have led some critics to accuse her of reinforcing limited standards of beauty for women.[17] Beecroft has responded by saying that she selects her models to suit the work – she often hires models from the local area – and, since 1997, she has composed tableaux using African and African American women, as well as men.[18] From her perspective, she approaches the bodies of her models in the way any artist would choose his or her medium. Just as a painter selects their pigment and a sculptor their stone, Beecroft chooses the models that she believes will best portray her concept in a performance.

Vanessa Beecroft

Vanessa Beecroft (born 1969)
VB62
12 July 2008
Performance
Santa Maria dello Spasimo, Palermo

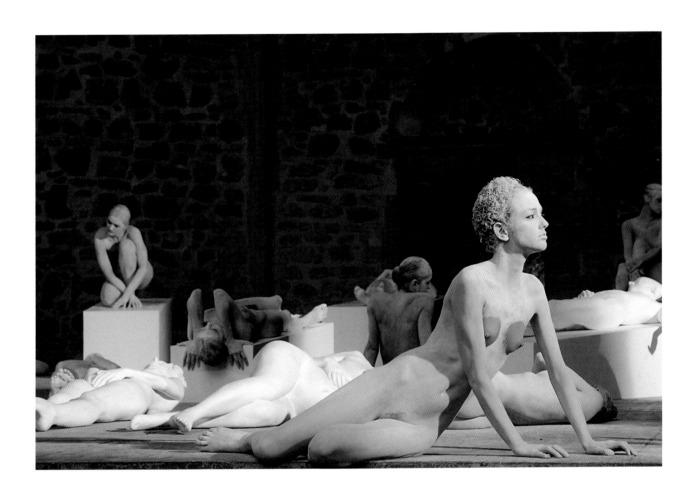

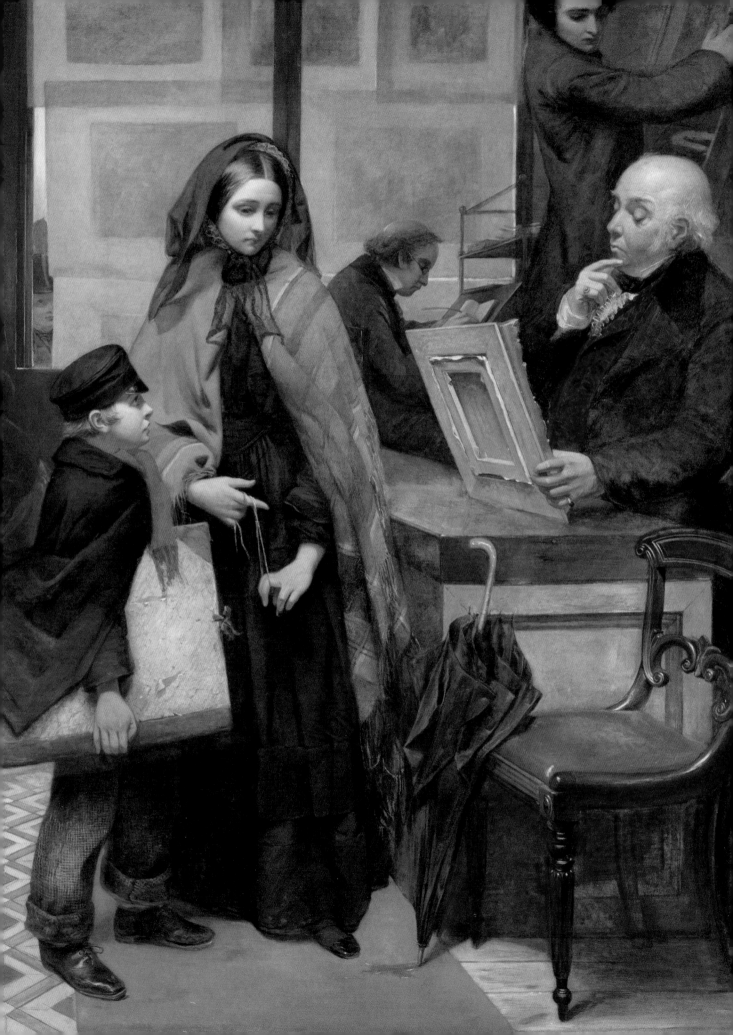

The way in which a story is told shapes the perception of its essential meaning. A stirring narrative can glorify heroes, expose enemies, proclaim truths and change minds. In this, a storyteller possesses genuine power, and although women have been trusted with passing on cultural tales, gender bias has dictated who gets to interpret the most significant stories. But women artists have appropriated subjects designated for men, and when they seize the narrative they empower a new and often dangerous point of view.

A new twist on an old tale can be an act of transgression, as well as one of transformation. Edmonia Lewis countered the romantic depiction of Cleopatra's demise with a shocking view of real death (page 91). Kiki Smith turned the tables on a grisly fairy tale by choosing an alternative ending (page 104). Isabel Bishop turned to the streets of New York City to discover a thoroughly modern protagonist (page 95), while Louise Bourgeois supplanted the menace of a monstrous spider with the nurturing force of maternal industry (page 98).

But it is in the telling of history, rather than legend, biography or fantasy, that the possession of power can best be contested. A new version of an old tale can expose the grim reality behind a romantic gloss (page 100), give voice to the voiceless (page 102) or question venerated acts of sacrifice (page 89). And history itself can be rewritten, as seen in Judy Chicago's alternative history of art (page 96), revealing that no matter how many times a narrative is repeated, it may not turn out to be true.

Seizing the Narrative

In *Nameless and Friendless*, English painter Emily Mary Osborn employs garments, gestures and gaze to stage a small drama about a distressed gentlewoman. The young woman (often identified as an aspiring artist) stands at the counter in an art gallery, waiting as the owner assesses a painting she has brought in to sell. Her little brother, holding the carrying crate, is her sole companion. The woman's plain black dress and bonnet, as well as her sorrowful expression, reveal that she is in mourning, and her anxiety about her newly vulnerable situation is betrayed by her downcast glance and the nervous way in which she fingers the packing string. Osborn highlighted the woman's straitened circumstances by adding a line from Proverbs to the painting's title when she exhibited the work at the Royal Academy of Arts in London in 1857: 'The rich man's wealth is his strong city, etc.' (10:15).[1]

To emphasize the young woman's plight, Osborn portrays two male customers, positioned to the left of the woman, who look away from a print of a ballerina to stare at her, as if she too were on display. In Osborn's day, middle-class women rarely ventured out alone; by appearing in public to conduct business with only her little brother at her side, this young woman has exposed herself as defenceless. She has nothing, and there is no one to protect her.

In the mid-nineteenth century, women in unfortunate circumstances had few options when it came to earning a living. The genteel orphan, forced to become a governess or to sell her own handiwork, offered a poignant narrative for such novelists as Charlotte Brontë (*Jane Eyre*, 1847) and her sister Anne (*The Tenant of Wildfell Hall*, 1848). Osborn, however, became a painter by choice. Her mother had trained and encouraged her. But her own experience of struggling to gain notice in a profession dominated by men gave her an empathetic insight into this young woman's situation.[2]

Emily Mary Osborn

Emily Mary Osborn (1828–1925)
Nameless and Friendless
1857
Oil on canvas
82.5 × 103.8 cm (32½ × 40⅞ in.)
Tate Collection, London

Elizabeth Thompson,
Lady Butler

Elizabeth Thompson, Lady Butler
(1846–1933)
The 28th Regiment at Quatre Bras
1875
Oil on canvas
97.2 × 216.2 cm (38¼ × 85⅛ in.)
National Gallery of Victoria, Melbourne

When Elizabeth Thompson's highly anticipated painting *The 28th Regiment at Quatre Bras* debuted at the Royal Academy of Arts in London in 1875, the art critic John Ruskin approached the work with scepticism. He doubted that any painting could live up to such laudatory advance notice, and confessed to holding an 'iniquitous prejudice': 'I have always said that no woman could paint.'[3] Ruskin had, in fact, been an advocate and mentor of women painters, but his 'prejudice' concerned the genre that Thompson had chosen. Battle painting had always been a man's field, but Thompson had established her career two years earlier with *Missing* (1873), a glimpse of a common soldier's heroism during the Franco-Prussian War (1870–71), and she quickly rose to fame.

In 1869, having completed her studies at the Female School of Art in South Kensington, London, Swiss-born Thompson moved to Italy with her family. During a visit to Paris in 1870, she became intrigued by the richly detailed work of such military painters as Édouard Detaille and Jean-Louis-Ernest Meissonier. Their compelling style, as well as the favour they found with the public, inspired Thompson to apply their techniques to the depiction of British military history, adding a human dimension to meticulous reportage by concentrating on the regimental soldiers rather than their famed leaders. *The 28th Regiment at Quatre Bras* portrays the successful repulse of French cavalry by British infantry – defiant in their distinctive headgear and scarlet tunics – at a decisive battle in 1815 between the allied troops of the Duke of Wellington and the French army led by Marshal Ney.

Along with other London critics, Ruskin praised *Quatre Bras*, describing the painting as 'Amazon's work'.[4] Thompson's ambition and talent enabled her to succeed in a male arena, and she continued to paint after her marriage to Sir William Butler, an army officer, in 1877.[5] However, the responsibilities of being an officer's wife took precedent over her career as a military painter.

The Death of Cleopatra debuted in Philadelphia at the Centennial Exhibition of 1876 to critical acclaim. In a contemporary article on Edmonia Lewis, subtitled 'The Colored Sculptress', Lail Gay singled out the work as a 'masterpiece' among the 500 submissions; elsewhere, J.S. Ingram decreed that it was 'the most remarkable sculpture in the American section'.[6] The wide recognition for Lewis's sculpture was not surprising; for more than a decade, Lewis's busts and figural groups had garnered critical and commercial success. Furthermore, her chosen subject was a crowd-pleasing favourite: such admired sculptors as William Wetmore Story and Thomas Ridgeway Gould had both won praise for their depictions of the demise of the legendary queen. But Lewis's interpretation was significantly different. While Story had represented Cleopatra contemplating her death (1858), and Gould had portrayed her submitting to the poison (1875), Lewis boldly depicted her sprawled lifeless on her throne. No one else had dared to confront the audience with a true image of death.

Born to an African American father and a mother of Ojibwe (or Chippewa) heritage, Lewis experienced a childhood that prepared her to defy convention. She was orphaned before the age of ten, but still managed to attain an excellent education in the Young Ladies' Department at Oberlin College in Ohio (1859–63) before launching her career in Boston in 1864.[7] One year later she settled in Italy, where she remained for the next twenty years. Although her previous work had attracted attention, in part for the novelty of her background – 'The Colored Sculptress' – *The Death of Cleopatra* ignited interest because of her interpretation of the subject rather than her identity. Writer William Clark Jr, who even questioned whether Lewis's unflinching account of the 'ghastly characteristics' of death might 'overstep the bounds of legitimate art', credited her daring authenticity and striking originality for giving form to a 'radically different' portrayal of the Egyptian queen.[8]

Edmonia Lewis

Edmonia Lewis (1844/45 – after 1911)
The Death of Cleopatra
1876
Marble
160 × 79.4 × 116.8 cm (63 × 31¼ × 46 in.)
Smithsonian American Art Museum,
Washington, D.C.

Natal'ya Goncharova with the Russian painter Mikhail Larionov (1881–1964). After working and living together for several decades, they married in 1955, a year before this photograph was taken.

Natal'ya Goncharova traced her interest in Russian peasant culture to childhood visits to her grandmother's home in Ladyzhino, a village in Tula Province. The surrounding rural community held to traditional ways, and Goncharova was fascinated by the colourfully dressed women, who kept their homes and worked the fields just as their ancestors had done over the centuries. Her own background was wealthy, middle class and educated, but she saw an essential spirit of 'Russian-ness' in the folkways of her grandmother's neighbours.

Equally influential was Goncharova's exposure to European avant-garde art. By the time she had enrolled at the Moscow School of Painting, Sculpture and Architecture in 1898, such forward-thinking Russian collectors as Sergei Ivanovich Shchukin were travelling to Paris and returning home with contemporary French paintings. Later, at *The Golden Fleece* exhibition of 1908, organized in Moscow by her companion and future husband, Mikhail Larionov (see left), Goncharova was inspired by the work of Matisse, Gauguin and Cézanne to create a uniquely Russian response to the avant-garde by adapting the experimental French approach to her own folk-art heritage. Goncharova began a series of paintings featuring peasant women that combined the formal innovations of the 'West' (Europe) with the material culture and habits of the 'East' (Russia).[9]

In *Bleaching the Sheets*, women carry rolls of freshly bleached linen. More strips have been spread on the ground to whiten in the sun. Goncharova has reduced the bodies of the women to weighty volumes, with columnar arms and legs rooted to the ground with large feet. The monumental figures and their bright garments have ethnic origins, but Goncharova fractures the surface of their clothes, as well as the cottages and fields in the distance, into patterns of prismatic colour. Seeking to combine traditional aesthetics with those of the avant-garde, Goncharova created a true convergence of 'East' and 'West'.

Natal'ya Goncharova

Natal'ya Goncharova (1881–1962)
Bleaching the Sheets
1910
Oil on canvas
105 × 117 cm (41⅜ × 46 in.)
The State Tretyakov Gallery, Moscow

In the mid-1920s Isabel Bishop rented a studio on Fourteenth Street near Union Square in New York. She had moved there from Detroit in 1918 to train as a commercial illustrator, but in 1920 she left the New York School of Applied Design for Women to study at the Art Students League. Her instructors, including Kenneth Hayes Miller and Guy Pène du Bois, encouraged her growing fascination with the life of the city, and Bishop quickly found a subject that would occupy her for the rest of her career: the urban working woman.

Bishop's move to New York had coincided with a rising post-war economy that presented new opportunities for women to enter the workforce. She felt an affinity with the salesgirls, telephone operators, secretaries and waitresses who took their breaks in and around Union Square. She, too, had moved to New York to make her living. Over the years she sketched women on the street and in the square – she also invited some of them to pose for her in her studio – catching them off guard as they ate their lunch, shared their secrets with one another or reapplied their make-up.

In *Tidying Up*, a woman stares into her compact, inspecting her teeth for lipstick smudges. Her little straw hat, adorned with an artificial flower, is fashionable but inexpensive. She is a modern 'working girl' – a shop clerk or a secretary – and her position has given her a sense of independence and upward mobility that was unknown to the women of her mother's generation. Bishop transforms this private moment, when the woman thinks no one is looking, into a telling subject that expresses from an empathetic point of view the verve and nerve of a new generation of women.

Isabel Bishop

Isabel Bishop (1902–1988)
Tidying Up
1941
Oil on Masonite
38.1 × 29.2 cm (15 × 11½ in.)
Indianapolis Museum of Art

American artist Judy Chicago's *Dinner Party* is grand in scale and intricate in media, and calls into question its viewers' presuppositions about art and history. The imposing installation consists of a large triangular table, elaborately set with thirty-nine distinctly individual place settings. Each setting is composed of a painted porcelain plate, cutlery, a napkin and a goblet placed on a textile runner embellished with the name of a woman. Each of the three corners of the table is covered with an embroidered cloth, while the table itself stands on a porcelain floor made from 2304 hand-cast and gilded lustreware tiles bearing the names of 999 more women to supplement the 'guests' at the table. The techniques employed by Chicago – china painting, sewing, weaving and embroidery – have traditionally been labelled as minor arts associated with women, but the scale of the work gives it monumentality. This is a deliberate choice: Chicago appropriated the grandeur of ceremonial art, allied with techniques long dismissed as 'women's work', to amend the historical record by inscribing women's names into the cultural narrative.

Some of the women are well known, such as Susan B. Anthony (1820–1906), a pioneer in the American struggle for women's rights. The butterfly form reposing on the plate – a vulval equivalent of the conventional phallic symbol – is dynamic, embodying the power needed to shatter repression. It sits on a fringed scarlet shawl, recalling a garment often worn by Anthony. The black-and-white runner, composed of 'memory bands', names some of the leaders and activists of the international Women's Movement; other such individuals are named on the floor tiles below the table.[10] By uniting the well-known figures of the movement – Anthony, Elizabeth Cady Stanton, Carrie Nation – with those who have previously gone unrecognized, Chicago seeks to amend the omissions of history. As just one setting in an ensemble of thirty-nine, *Susan B. Anthony* represents Chicago's commitment to art that is challenging, complex and dedicated to celebrating the female narrative long obscured by the male-dominated vision of the world.

Judy Chicago

Judy Chicago (born 1939)
The Dinner Party (detail; *Susan B. Anthony* place setting)
1974–79
Ceramic, porcelain and textile
Brooklyn Museum of Art, New York

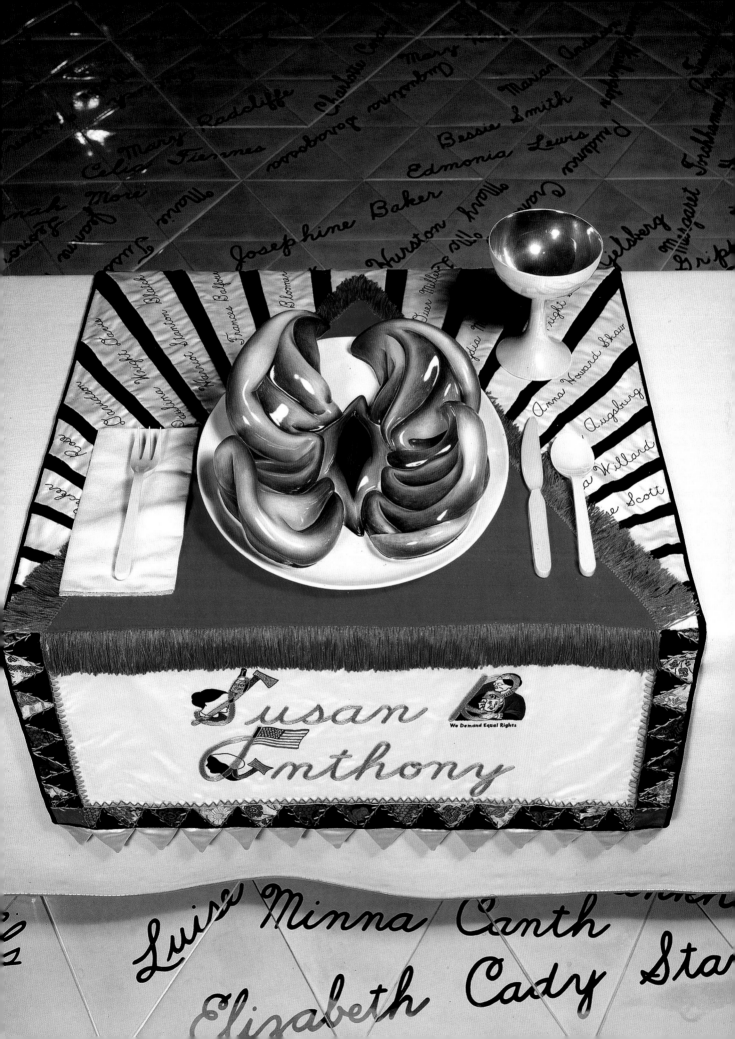

Louise Bourgeois with her marble sculpture Femme Maison *(1981) at her retrospective of 1982–83 at the Museum of Modern Art, New York.*

In her poem 'Ode à ma mère', written to introduce a suite of prints, Louise Bourgeois – an American artist of French birth – likened her mother to a spider. Their qualities of character were the same: both were deliberate and clever, dainty and neat, and, above all, patient, industrious and useful. Bourgeois proclaimed that her mother was her 'best friend' and an inspiration to her art: 'I shall never tire of representing her.'[11] Throughout Bourgeois's career, the spider was her potent symbol of womanly industry and an embodiment of an essential force in her own art.

During Bourgeois's childhood in Paris, her parents sold antiques and restored tapestries. Bourgeois sharpened her drawing skills by sketching out patterns for the parts of the tapestries that were worn or missing. When the spider first appeared in her own work, in a drawing of 1947, she realized that the act of weaving and the act of drawing were closely connected. She explained that drawing 'is a secretion, like a thread in a spider's web'.[12] In the 1990s she created a series of spider sculptures, ranging from the small cast bronze seen here to the towering *Maman* (1999), a monumental steel installation with tensed legs and a wire-mesh sac filled with marble eggs.

The mythological aspects of the spider appealed to Bourgeois. In common with Penelope, the faithful wife of Odysseus, the spider's patience is endless; similarly, its skills, like those of the mortal weaver Arachne, rival those of the gods. Bourgeois believed that she best expressed her own feminism in 'an intense interest in what women do'.[13] But the true significance of the spider was more intimate: it celebrated her mother in a strong symbol stripped of all sentiment. Bourgeois was proud to have been born into 'a family of repairers', who, like a spider facing a tattered web, simply surveyed the damage and got on with the repairs without anger or retribution.[14]

Louise Bourgeois

Louise Bourgeois (1911–2010)
Spider II
1995
Bronze wall piece
57.2 × 185.4 × 185.4 cm (22½ × 73 × 73 in.)
Munson-Williams-Proctor Arts Institute, Utica, New York

To Kara Walker, the art of the silhouette is the perfect medium for racially charged imagery; with a twist of irony she points out that 'everyone is black' in a silhouette.[15] She traces her interest in cut-paper figures to the beginning of her studies at the Rhode Island School of Design (1992–94), when she saw a reproduction of a nineteenth-century silhouette of a young black girl in a book on American art. The image was rich with potential. Not only did it summon up the agonized history of American racial conflict, but also, by negating surface detail, the blank surface allowed ambiguity to germinate and thrive. Here was a different way to tell a story, and the story that most intrigued Walker was that of America's antebellum South.

Slavery! Slavery! was conceived in the form of a cyclorama, a large panoramic scene set on the inside of a cylindrical surface, especially popular in the 1800s as a means of depicting great moments in history.[16] The extended title of the work employs the hyperbolic language typical of a nineteenth-century cyclorama: *Presenting a GRAND and LIFELIKE Panoramic Journey into Picturesque Southern Slavery … by the able hand of Kara Elizabeth Walker, an Emancipated Negress.*[17] But her chaotic narrative crushes any romantic interpretation of the antebellum South, from genteel life on the plantation to noble behaviour under enslavement. Walker's characters couple on rooftops, defying the miscegenation taboo. A baby hatches out of a watermelon, near a grandmother who holds the hand of a dancing child but hides a knife behind her back. Stereotypes abound – the jigging shaman, the belles in their hoop skirts, the old man with his pitchfork – and Walker's imagery has incurred the anger of some older African American artists who question her motives.[18] But Walker defends her incendiary iconography; as she sees it, storytelling implicates everyone, including the artist, the viewer and the characters that they view.

Kara Walker

Kara Walker (born 1969)
Slavery! Slavery! (detail)
1997
Cut paper and adhesive on wall
Collection of Peter Norton Family
Foundation

Shirin Neshat left Iran to move to the United States with her family in 1974, and by the time of her first return visit in 1990, both she and her homeland had changed dramatically. After earning a Master of Fine Arts at the University of California, Berkeley (1982), Neshat had relocated to New York to run a not-for-profit art gallery, where she organized conferences as well as exhibitions addressing cross-disciplinary expression in art. The life she came to live would have been impossible in Iran after the Islamic revolution of 1979. Over the course of a decade, women's lives were redefined: their roles moved from the public to the private sphere, and they were required to veil themselves outside their homes. Following her visit to Iran, Neshat felt 'haunted' by the transformation of 'people's physical appearance and public behavior'.[19] To understand better the convergence of submission and strength she had seen in the participation of Iranian women in the revolution, she undertook a series of photographs that she called *Women of Allah* (1993–97).

The staged photographs feature veiled women with firearms, their skin apparently embellished with calligraphy. Neshat's own face appears in *Speechless*. Her wide-eyed, mournful look is resolute, while the barrel of the gun that protrudes from her veil near her right cheekbone has a strange, ornamental quality. The text, a poem by the Iranian poet and academic Tahereh Saffarzadeh, speaks the words of a woman who wants to join her brothers in martyrdom. Neshat does not judge the woman and her motives; she believes that polarized views prevent debate. Rather, she seeks to give a voice to the inner turmoil of a woman whose life is fraught with contradiction: fierce devotion to her faith and to the revolution that has excluded her from action in the public arena and confined her to her home.[20]

Shirin Neshat

Shirin Neshat (born 1957)
Speechless
1996
From the series *Women of Allah*, 1993–97
RC print and ink
167.6 × 133.4 cm (66 × 52½ in.)
Gladstone Gallery, New York

Folklore and traditions fascinate the German-born American artist Kiki Smith. Throughout her career she has been an avid reader of legends and folk tales, and has collected prints – ranging from crude woodcuts to elaborate coloured imagery – that illustrate them. Although she is better known for her sculpture, Smith has been a dedicated printmaker since the mid-1980s, and believes that works of art on paper have an inherent populist dimension. The reproduction of an image in a relatively modest medium expands its audience, and Smith believes that, as a result, 'people are empowered through printmaking'.[21]

Smith has unleashed the power of the populist narrative in her graphic art, as seen in *Born*, an image inspired by the fairy tale *Little Red Riding Hood*. The story has been traced back to the seventeenth-century French folk tale *Le Petit Chaperon rouge*, but it is best known today in two different versions, one recorded by French folklorist Charles Perrault in *Histoires ou contes du temps passé* (1697), and the other by the Brothers Grimm in *Kinder- und Hausmärchen* (1812). In Perrault's telling, the girl and her grandmother are eaten by a wolf; in that of the Brothers Grimm, they meet a similar fate but are then saved by a hunter, who slices open the wolf's stomach and releases them. In common with the Brothers Grimm, Smith saves the girl and the grandmother, but she envisions the episode as a birth rather than a rescue. There is no evidence of the hunter, while the wolf, snarling through bared and bloodied teeth, convulses as if in labour as the woman and the child rise unharmed from its body.

Smith displays no hesitation when it comes to altering her source narratives in order to unleash new potential from old stories. By choosing to modify the familiar tale of *Little Red Riding Hood*, she purposefully distorts the expectations that viewers may bring to her imagery, forcing them to construct their own meanings, which may stray far from traditional associations. Through her unorthodox and unexpected portrayal, the familiar tale is detached from its conventional warning against the dangers of appetite and sexuality in order to celebrate the fierce power of regeneration that binds mother and child.

Kiki Smith

Kiki Smith (born 1954)
Born
2002
Lithograph
Image: 173 × 141.5 cm (68⅛ × 55¾ in.);
sheet: 173 × 142.5 cm (68⅛ × 56⅛ in.)
No. 1 in an edition of 28
The Museum of Modern Art, New York

With ideas that incite and images that offend, some artists deliberately court danger. And this raises an intriguing question: does the perception of what is and what is not dangerous in art change when the artist is a woman? Women artists have always been bound by more restrictions; at times, even simply making art was an act of resistance. But for some women artists, opposition itself is the source of inspiration, and these women have boldly confronted taboos and upended expectations by refusing to play it safe.

From a woman's perspective, old tales can convey new truths. In common with many male painters of her generation, Artemisia Gentileschi depicted the biblical heroine Judith, but her own personal history added the force of retribution (page 109). Elizabeth Catlett revealed that a different point of view can empower the oppressed (page 115), while Käthe Kollwitz used her art to confront authority (page 111). Renée Stout, meanwhile, discovered that, through art, women can revitalize powers that have lain dormant for generations (page 118).

But are some issues just too incendiary to address? Are some images too provocative to represent? Such artists as Meret Oppenheim, Marina Abramovic and Tracey Emin would say not; they were willing to risk revulsion, shock, pain and exposure (pages 112, 116 and 126, respectively). Deeply held assumptions about gender, sexuality and faith can be confronted when an artist refuses to flinch in the face of opposition to her views (pages 122 and 124). And even the art world can be taken to task when such women as the Guerrilla Girls dare to play with danger (page 120).

Playing with Danger

Leaving the city of her birth, Artemisia Gentileschi moved from Rome to Florence to join her husband, Pietro Stiattesi, whom she had married in November 1612.[1] Rome held ugly memories for her. Earlier that year her father, the prominent painter Orazio Gentileschi (1563–1639), had charged a fellow artist, Agostino Tassi (c. 1580–1644), with the rape of his daughter. Tassi had a criminal record – he had been incarcerated before on similar charges – and he was convicted of his crime against Gentileschi. But in the course of the seven-month trial, she was tortured with thumbscrews to test the validity of her testimony, and her reputation was damaged by the very public scandal of the trial.

Both Gentileschi and her father had painted subjects based on the deuterocanonical Book of Judith, but this work, *Judith and Her Maidservant*, bears a particular significance in terms of the development of Gentileschi's career. She painted it when she resumed her career away from Rome, and the restraint with which she interprets the narrative reflects her renewed strength of character after the humiliation of her trial. Judith was a beautiful Judean widow. When the Assyrian general Holofernes laid siege to her village in his march from Nineveh to Jerusalem, Judith donned her finest garments and coaxed him into trusting her. On the fourth night of their encounter, she took advantage of his intoxication, seized his sword, and beheaded him. With the head in a basket, she and her servant, Abra, left the enemy camp, and, without their fierce general, the invaders were defeated.

Conventional depictions of Judith – including others by Gentileschi – focus on the death of Holofernes at Judith's hands.[2] But here, Gentileschi has chosen to portray a moment after the beheading, presenting the women as wary, still watching as they leave the camp with their grisly trophy. Judith has succeeded in an unthinkable act of grim justice, but she does not revel in her triumph. She has nothing more to prove; in common with Gentileschi, her dignity marks her authentic heroism.

Artemisia Gentileschi

Artemisia Gentileschi (1593–1654)
Judith and Her Maidservant
c. 1618–19
Oil on canvas
114 × 93.5 cm (44⅞ × 36¾ in.)
Palazzo Pitti, Florence

In 1893, at a performance in Berlin of Gerhart Hauptmann's play *The Weavers* (1892), Käthe Kollwitz encountered the subject that forged the direction of her career. Two years earlier, influenced by artist Max Klinger's treatise *Malerei und Zeichnung* (Painting and drawing; 1891), Kollwitz had been seeking a way to use her printmaking for social good. She had considered illustrating Émile Zola's realist novel *Germinal* (1885), an exposé of working conditions in French mines, but Hauptmann's powerful drama, based on the Silesian weavers' revolt of 1844, better reflected her socialist views and her concern for women workers. Kollwitz was not alone in recognizing the political potency of the play; after a few performances at the Grosse Berliner Kunstausstellung, it was banned for subversive content.

Between 1893 and 1897 Kollwitz worked on a six-part suite of prints – three lithographs and three etchings – that followed the struggles of the weavers as they fought against wage cuts and job losses; textiles produced in mechanized mills at a higher volume and lower cost had put their trade in jeopardy. The employer turned a deaf ear to their strike, and, in the face of hard resistance, the weavers marched to his mansion. The fifth scene, *Storming the Gate*, portrays the women gathered outside a locked entrance; some of them dig up the cobblestones with their bare hands, preparing for confrontation. The woman on the right holds the hand of her weeping child and, in her other arm, a baby, reminding the viewer that this struggle hurt the most vulnerable in society: poor working women and their children. When the suite was completed, Kollwitz exhibited the prints at the Berlin Salon of 1898. The esteemed painter Adolph Menzel nominated her for a gold medal, but Kaiser Wilhelm II blocked the award. In a chilling reprise of the censorship of Hauptmann's play, the kaiser deemed Kollwitz's prints too subversive to be seen by the German public.

Käthe Kollwitz

Käthe Kollwitz (1867–1945)
Storming the Gate, plate 5 from the series
A Weavers' Revolt
1897
Etching overworked with sandpaper
Image: 23.7 × 29.5 cm (9⅜ × 11⅝ in.)
The State Hermitage Museum,
St Petersburg

Meret Oppenheim, a Swiss painter and sculptor of German birth, attributed the inspiration for her notorious fur-lined teacup to a casual conversation in 1936 with Pablo Picasso and Dora Maar at the Café de Flore in Paris. To supplement her income as a young and, as yet, unrecognized artist, she was designing jewellery. Picasso admired her fur-covered bracelet, and the trio playfully pondered what else could be covered in fur. Oppenheim glanced at the table setting and asked, 'Why not this cup, saucer and spoon?' Not long afterwards, when the French Surrealist writer André Breton (1896–1966) invited Oppenheim to participate in an exhibition at the Galerie Charles Ratton, she purchased a cup, a saucer and a spoon, and covered them with fur from a Chinese gazelle.[3] The assemblage, simply called *Object*, was displayed in a vitrine, surrounded by a random collection of 'ready-mades' (found and altered objects), plants, minerals and carvings from non-European cultures. Alfred H. Barr, the founding director of the Museum of Modern Art in New York, purchased the work, and when it was featured in the museum's landmark exhibition *Fantastic Art, Dada, Surrealism* (1936–37), it gained iconic status as an embodiment of the Surrealist challenge to mundane expectations.

With *Object*, Oppenheim subverts a comforting and domestic ritual by merging the familiar and the strange. The sensuality of the glossy fur – as well as the repellant prospect of finding hair in a cup – violates the decorum of teatime. In a further act of provocation, Breton renamed the work *Le Déjeuner en fourrure* (Luncheon in fur), linking it to previous works that had scandalized Paris: Édouard Manet's painting *Le Déjeuner sur l'herbe* (1863) and Leopold von Sacher-Masoch's erotic novella *Venus im Pelz* (1870). But the work's ability to shock lies not in its title, but in a disturbing materiality that subverts the assumption that an object will passively comply with its intended use.

Meret Oppenheim

Meret Oppenheim (1913–1985)
Object (Le Déjeuner en fourrure)
1936
Fur-covered cup, saucer and spoon
Cup: diameter 10.9 cm (4¼ in.); saucer: diameter 23.7 cm (9⅜ in.); spoon: length 20.2 cm (8 in.); overall height: 7.3 cm (2⅞ in.)
The Museum of Modern Art, New York

In 1946 Elizabeth Catlett left the United States for Mexico. There, she secured a position as a guest artist at the Taller de Gráfica Popular, a printmaking collaborative established in 1936 to develop public art as an agent of social change. Catlett traced her interest in Mexican contemporary art to her involvement with the US government's Public Works of Art Project a decade earlier, when, as an assistant to American muralists, she had studied the works of such masters of the mural as Diego Rivera (1886–1957). Catlett also embraced socialist ideals, and she realized that the increasingly repressive Cold War climate of post-war America threatened her progressive politics.[4] She found a congenial community at the Taller de Gráfica Popular, and although she worked primarily in sculpture, their preferred medium of the linocut suited her purpose. In Catlett's view, linocuts 'put art to the service of the people'.[5]

Catlett carved the linoleum block for the print *Sharecropper* in 1952, using it to create new editions of the work for more than a decade, sometimes adding bold colour to enhance the impact of the print. After the American Civil War (1861–65), sharecropping, a form of tenant farming, developed across the American South as former slave owners sought to revive the fortunes of their plantations with cheap labour. Sharecropping was especially hard on newly emancipated African American workers, who often found themselves and their families trapped for generations by this system of indentured rural labour. But Catlett portrays the sharecropper not as a victim, but as a woman of inherent dignity and resolute strength. The image extended Catlett's exploration of the contributions of black women to American society, which she had launched with the linocut series *The Negro Woman* (1946–47).[6] Recognition was the first step in correcting the historical record, and Catlett made her art a powerful tool in that process.

Elizabeth Catlett

Elizabeth Catlett (1915–2012)
Sharecropper
1968–70
Linocut
Image: 44.8 × 43 cm (17⅝ × 16⅞ in.)
The Museum of Modern Art, New York

Visitors to the opening of the performance festival held in June 1977 at Bologna's Galleria Comunale d'Arte Moderna had a disconcerting experience before they had even entered the museum. Marina Abramovic and her partner, Ulay (Frank Uwe Laysiepen; born 1943), were standing opposite each other, naked, in the deliberately narrowed entranceway, forcing museum patrons to squeeze between them. They flanked the doorway in the manner of statues, but their presence coerced visitors into action. Would they willingly pass through the limited space between the two bodies knowing that they had to brush against a stranger's bare flesh? How should they react to this unwanted but unavoidable contact? And, most importantly for Abramovic, would they face her or Ulay? The performance, which was scheduled to last for 3 hours, was ended by police intervention after 90 minutes.

Born in Belgrade, Abramovic calls herself a body artist, and for more than three decades she has tested her medium through fasting, cutting, screaming, allowing others to handle her and keeping absolutely still in challenging circumstances. She has repeatedly referred to her collaborations with Ulay (1976–88) as her deepest exploration of the psychological and physical boundaries of personal identity and trust, but her solo performances, in which she simultaneously intrigues and appals her audience, are just as riveting. She describes the trajectory of her project as 'Art Vital', in which there is 'no rehearsal', 'extended vulnerability' and 'exposure to chance'.[7] And she is absolutely fearless, willing to put her body in jeopardy and make the audience intensely uncomfortable. Although documentary photographs and films preserve her performances, Abramovic regards the element of being present as essential to the experience of her work. Thus, for her retrospective at the Museum of Modern Art in New York in 2010, she re-staged a number of her performances – including *Imponderabilia* – using substitute performers. This time, the museum offered visitors an alternative entrance.

Marina Abramovic

Marina Abramovic (born 1946)
Imponderabilia
June 1977
Performance
Galleria Comunale d'Arte Moderna,
Bologna

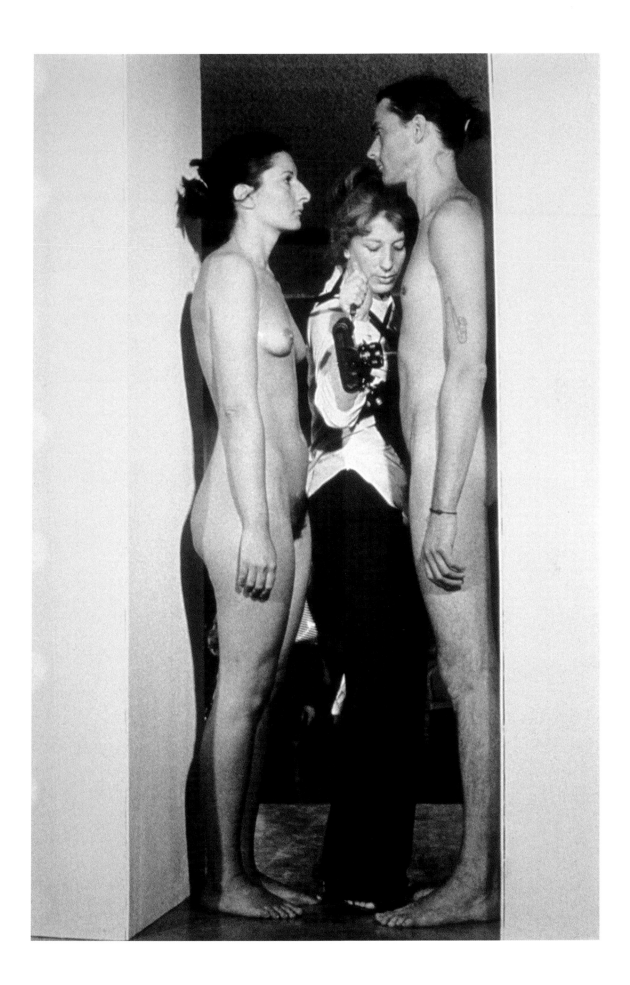

Renée Stout was ten years old when she first saw a *nkisi nkondi* from the Kongo cultures of West Africa in the Carnegie Museum of Art in Pittsburgh; she did not know what it was, but she found the compact wooden figure, with its mantle of bristling nails, absolutely compelling. Twenty years later she created her own *nkisi* by casting her body in plaster, painting it black and embellishing it with ornaments. Over the years, Stout had explored a variety of media – paint, sculpture and installation – but two concerns united all her work: her spiritual heritage and a dedication to creating art that protects and heals. As a child, she had been aware of older, unexplained family customs, which she later recognized as the legacy of the African diaspora;[8] as a young woman living in Washington, D.C., she had frequented a shop that sold traditional roots and herbs for healing practices. Stout came to see her art as a place of convergence, bringing together beauty and utility. And the *nkisi nkondi* – a power figure – was the perfect vessel for containing that potent mix.

In the vocabulary of Kongo ritual, a *nkisi* is a container for powerful substances. A *nkisi nkondi* takes the form of a hunter. While the figure embodies strength, its most important feature is a chamber that holds the *bilongo*, or medicine. To arouse the figure's power, for sealing an oath or to revenge oneself on another, for example, a *nganga* (ritual specialist) pounds a nail into the figure.[9] Although no nails puncture the body of *Fetish #2*, the figure exudes strength through its stance. And the glass-walled chamber in its abdomen contains meaningful objects: an old family photograph, a dried flower and a postage stamp from Niger. Stout, who regards the work as a self-portrait, references an old belief that 'ancestors only lose their power when you forget them'.[10] By using her own likeness, Stout has sworn to remember them in the most powerful way.

Renée Stout

Renée Stout (born 1958)
Fetish #2
1988
Mixed media and plaster body cast
Height: 162.6 cm (64 in.)
Dallas Museum of Art

In 1989 the Public Art Fund (PAF) of New York commissioned a billboard design from the art collective known as the Guerrilla Girls. As an anonymous group dedicated to raising awareness about inequality in the art world, they eagerly seized the opportunity to address the public on such a grand scale. They went to the Metropolitan Museum of Art to carry out some research – what they called a 'weenie count' – and included their findings about the ratio of male artists to female artists, as well as that of female nudes to male nudes, within the body of the poster.[11] A nude woman in repose graced their design. The figure re-created the iconic nude in Jean-Auguste-Dominique Ingres's *Grande Odalisque* (1814), with one notable alteration: the demure head of Ingres's idealized concubine had been engulfed by a giant gorilla mask. The PAF, citing lack of clarity, rejected the design.[12]

The Guerrilla Girls were formed in 1985 to protest the poor representation of women artists in the exhibition *An International Survey of Recent Painting and Sculpture* held the year before at New York's Museum of Modern Art; despite its claim to be a definitive account of art in the late twentieth century, the exhibition included only thirteen women out of a total of 169 artists. At first, the Guerrilla Girls signed the posters that they plastered around Manhattan 'The Conscience of the Art World', but they soon adopted their current name to reflect their identity as a covert and transgressive force. To remain anonymous, they adopted the names of historic women artists – Rosalba Carriera, Käthe Kollwitz and Frida Kahlo, among others – and appeared in public in disguise, wearing black garments and gorilla masks.[13] Over the years they have continued their stealth campaign, and a recent version of *Do Women Have to Be Naked* … reveals that their work is far from done. In it, their updated statistics for the Met show that, as of 2011, the numbers for women – 4 per cent of the painters in the modern collection, and 76 per cent of the nudes – are still unacceptable.

Guerrilla Girls

Guerrilla Girls
Do Women Have to Be Naked to Get into the Met. Museum?
1989
Offset lithographic poster
Dimensions variable
Courtesy of guerrillagirls.com

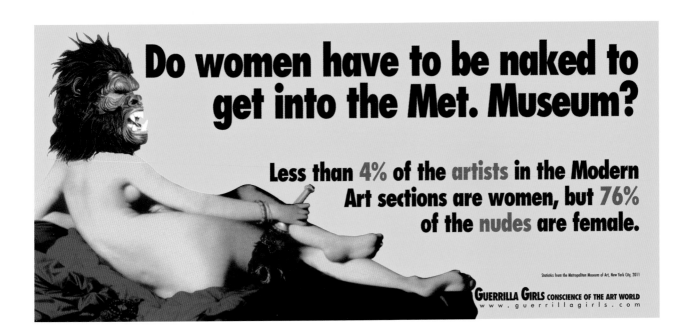

American photographer Catherine Opie describes her photographs of Bo as a representation of a 'persona', rather than a portrait. Born out of her imagination and given physical form through her own body, Bo is perceived by Opie not as a character in a narrative but as a type: he might be 'a used aluminum-siding salesman from Sandusky, Ohio'.[14] But he is also Opie, whose full torso, heavy arms and cherubically rounded cheeks undercut the image of aggressive masculinity projected by the clothes, moustache, stance and gaze. Opie included an earlier photograph of Bo in *Being and Having* (1991) and this one in *Portraits* (1993–97), her landmark series of photographs of her friends from the Los Angeles leather community, a gay subculture that wears leather to signify heightened sexuality and fetishism. She was inspired by her sitters' open display of unconventional gender identities and sexual preferences; these were people 'giving themselves the freedom to image themselves however they saw fit'.[15] At a time when the popular media was beginning to explore – and exploit – ideas of transsexual identity and body modification, Opie saw her work as a counterbalance: 'It [the media coverage] was all about the body, but I wanted it to be about the person as well.'[16]

Opie does not equate her 'persona portraits' of drag kings and queens, transsexuals and butch lesbians with the photographic scenarios staged by such artists as Jeff Wall and Cindy Sherman (page 57); the appearance of her sitters may be constructed, but it is genuine. Instead, Opie feels a deep connection with two outstanding portraitists of the past: Hans Holbein the Younger (1497/98–1543), who gained international renown painting portraits in the court of Henry VIII, and August Sander (1876–1964), who devoted his career to photographing the people of Westerwald near Cologne for the magisterial series *Menschen des 20. Jahrhunderts* (c. 1910–1950s). In common with these artists, Opie's vision is informed by the unblinking honesty with which she conveys the dignity of personal identity in all its variants.

Catherine Opie

Catherine Opie (born 1961)
Bo
1994
From the series *Portraits*, 1993–97
Chromogenic print
152.4 × 76.2 cm (60 × 30 in.)
Edition of 8
Regen Projects, Los Angeles

Renée Cox

Renée Cox (born 1960)
Yo Mama's Last Supper
1996
Colour coupler prints
Five panels, each 50.5 × 50.5 cm
(19⅞ × 19⅞ in.)
Private collection

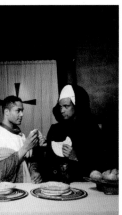

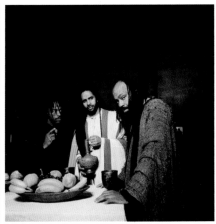

In February 2001 Renée Cox's multi-panel photograph *Yo Mama's Last Supper* caused a furore when it was shown at the Brooklyn Museum of Art in New York as part of the exhibition *Committed to the Image: Contemporary Black Photographers*. Since 1992 Cox had photographed herself as 'Yo Mama', one of two alter egos that she had created to confront stereotypes of African American women.[17] The photographs emphasized womanhood, presenting Cox hugely pregnant in *Yo Mama at Home* (1992) and with her sons in *Yo Mama* (1993), *Yo Mama (the Sequel)* (1996) and *Yo Mamadonna and Child* (1996). In all but the last, Cox appears nude, and her athletic body projects a fierce confidence. She is also nude in *Yo Mama's Last Supper*, a reprise of Leonardo da Vinci's iconic depiction of the Last Supper in the refectory of Santa Maria delle Grazie, Milan (1495–1497/98).

In Cox's version, all the disciples except Judas are black. As in Leonardo's composition, they are dressed in robes and gathered in four groups of three on either side of the central figure, in this case Cox. Her most outspoken critics, including Rudolph Giuliani – in reaction to the work, the then major of New York called for the formation of a 'decency panel' to evaluate works featured in publicly funded art projects – cited the nudity of the figure representing Christ, rather than the figure's race or gender. In 2001, in a debate sponsored by the American advocacy group the First Amendment Center, William A. Donohue, president of the conservative Catholic League for Religious and Civil Rights, told Cox that he would not have been offended 'if you had kept your clothes on'. But Cox remained sceptical about how comfortable her critics were with a black woman appropriating the position traditionally held by Western culture's most revered white man. She maintained her right to use art to critique her experience, and argued that she had done exactly what Leonardo had, that is, portray the Last Supper 'with people who look like him'.[18]

Tracey Emin makes her art out of the details and detritus of her life. In 1998, for her installation *My Bed*, the British artist gathered up the soiled and rumpled contents of her bedroom – dirty sheets and pillowcases, damp towels, discarded cigarette packets and tissues, empty bottles, condoms – and transferred them to a gallery, confronting viewers with a no-holds-barred narrative based on self-exposure. One year later, having been shortlisted for the Turner Prize, Emin set up *My Bed* again, this time in the hallowed halls of the Tate Gallery (now Tate Britain) in London. Her work became a media sensation; coverage of *My Bed* ranged from serious, critical reflection on the boundaries between art and life to tabloid accounts of horrified mothers complaining that the exhibition of such work validated immoral behaviour.[19]

Throughout her career, Emin has been a storyteller, and the stories she tells are blunt, raw and graphic. She has laid open her life to public scrutiny, but her art is as confrontational as it is confessional. She exposes what society expects to be hidden, and although her work often elicits shock, it seeks neither approval nor absolution. Emin never recoils from the harsh realities of her own experiences: the privations of her childhood, the trauma of teenage rape and abortion, and her own youthful indiscretions in the pursuit of romance and sexual satisfaction. When interviewed by the London edition of the *Big Issue* during the furore that surrounded the opening of the Turner Prize exhibition, Emin boldly stated, 'What I'm doing is a life-long project.'[20] Emin's appetite for self-examination has been neither diminished nor sated. She continues to put her life on display, with the banal, mundane activities of a middle-aged woman now placed alongside the sensational exploits of her younger self.

Tracey Emin

Tracey Emin (born 1963)
My Bed
1998
Mattress, linens, pillows and
miscellaneous objects
79 × 211 × 234 cm (31⅛ × 83⅛ × 92⅛ in.)
The Saatchi Gallery, London

More than just a likeness, a self-portrait is an assertion of identity.
It is the same for a man as for a woman, but when a woman paints her
own portrait she overturns the traditional power of the male artist to
determine the public perception of the female subject. By crafting her
own image, she presents herself as she wishes to be seen. Throughout
the centuries this type of artistic control has been the prerogative of
self-portraiture, and, in common with men, women have used their own
images as a persuasive means of promoting their careers, proclaiming
their fame and situating themselves both in their contemporary world
and for posterity.

Sofonisba Anguissola (page 130) painted her own image
throughout her life, from playful adolescence to dignified old age.
Others used self-portraiture to assert their professionalism (page 134)
or launch new phases of their careers (page 139). A self-portrait can
project confidence, symbolized by the champion's crown worn by
Rosalba Carriera in a late-life image (page 132). Alternatively, a woman
artist can assure her admirers that she possesses womanly virtue –
as well as manly talent – as seen in Elisabeth Vigée-Lebrun's
self-incarnation as ideal modern maternity (page 136).

Self-portraits can also have private meanings. The ambiguous
symbols in Surrealist self-portraits (pages 142 and 144) fascinate but
resist full interpretation. Frida Kahlo, whose self-examination was
unrelenting, cast herself as a mythic figure, portrayed through a unique
and personalized iconography (page 146). And sometimes, likeness itself
is as enigmatic as it is intimate, as Elizabeth Peyton (page 148) reveals
in her own image.

In Her Own Image

Throughout her long and active life, Sofonisba Anguissola painted
self-portraits. The earliest known example is a chalk sketch of a laughing
girl (*c.* 1545), who teasingly points to her elderly companion; the last
is a formal portrait in oil (*c.* 1620), which conveys her dignity and
self-possession in old age.[1] However, most of her self-portraits date
from between 1549, when she left her home in Cremona to undertake
six years of art training in Milan, and 1559, when she moved to Madrid
to take up a position in the court of Philip II. Throughout this critical
decade in her development as an artist, and even during her first years
in Madrid, she explored the many potential facets of her identity: a
wide-eyed young woman holding a small open book inscribed with the
words 'Sofonisba Anguissola virgo' ('virgo' meaning 'maiden'; 1556);
a charming lady playing a clavichord (1561); and as the face in a portrait
being painted by Bernardino Campi, her teacher (late 1550s).[2]

Here, Anguissola presents herself as an accomplished painter.
Although the image on her easel – the Virgin Mary gently caressing her
child – has not been connected with an independent work, it appears
in other versions of this portrait that Anguissola painted in subsequent
years.[3] As in all her self-portraits of this prolific period, Anguissola is
modestly dressed in a black high-necked gown with a bit of lace trim at
the neckline and the cuffs. Her hair is simply arranged in a coronet of
braids. As she lifts her brush to her easel, steadying her right hand on the
mahlstick in her left, her demeanour, as much as her actions, conveys the
seriousness of her professional aspirations. Turning away from her easel
with a slightly stern expression on her face, Anguissola seems intent on
dealing with the distraction of acknowledging the viewer and getting
back to her work.

Sofonisba Anguissola

Sofonisba Anguissola (*c.* 1532–1625)
Self-Portrait
1556
Oil on canvas
66 × 57 cm (26 × 22½ in.)
Museum Zamek, Lancut, Poland

During the early decades of the eighteenth century, few artists – male or female – could rival Rosalba Carriera's innovations and accomplishments. As a young woman living in her native Venice, she had followed her mother's example and made lace. However, her talent for capturing a likeness prompted her to switch to painting miniatures, and she is widely credited with being the first miniaturist to substitute ivory for vellum to create a more luminous surface. Even more influential was her work in pastel; her free handling of the medium, combining the qualities of a painterly brushstroke with those of a calligraphic line, lent the relaxed poses and engaging facial expressions of her portraits an aura of grace and elegance.

In 1720, during a trip to Paris, Carriera won acclaim for a lifelike pastel portrait of the young Louis XV. In recognition of her talent, she was granted the status of *académicienne* in the French Académie Royale de Peinture et de Sculpture, becoming the first foreign woman to receive such an honour. Two generations of portrait painters, including such pastel masters as Maurice-Quentin de La Tour and Jean-Baptiste Perronneau, as well as such notable women painters as Adélaïde Labille-Guiard (page 134) and Elisabeth Vigée-Lebrun (page 136), adopted her lively and sophisticated approach.

Carriera painted several self-portraits late in her career, and this work dates from some time before 1746, when her sight began to deteriorate. Her sober expression, as well as the laurel wreath that crowns her silver hair, has prompted some scholars to assign the portrait an allegorical title: *The Artist as Tragic Muse*.[4] But, in the fading light of a spectacular career, which included commissions from the most prominent aristocratic families of Europe, as well as from several reigning monarchs, it is just as likely that the laurel wreath designates Carriera as a champion of her profession.[5]

Rosalba Carriera

Rosalba Carriera (1675–1757)
Self-Portrait
Before 1746
Oil on paper
31 × 25 cm (12¼ × 9⅞ in.)
Gallerie dell'Accademia, Venice

In 1783 Adélaïde Labille-Guiard was granted membership of the prestigious Académie Royale de Peinture et de Sculpture. As an *académicienne* – at the time, an accolade enjoyed by only three other women – Labille-Guiard held the right to teach in her studio and exhibit her work at the official Salon.[6] Two years later, in the Salon of 1785, she confirmed her new status with this triple portrait, which displayed her confidence and ambitions. Labille-Guiard depicts herself seated at her easel with two of her pupils, Marie-Gabrielle Capet and Marie Marguerite Carreaux de Rosemond, standing behind her. Every detail, from the tacked edge of the canvas to the lustrous sheen of Labille-Guiard's dress, attests to her keen observation and consummate skill. But through this work, Labille-Guiard sought to display more than her flair for portraiture; with careful staging and superb craft, she celebrated female accomplishment in a male-dominated profession.

The audacious scale of the canvas – the figures are almost life-size – was calculated to catch the viewer's eye in an exhibition crowded with paintings, hung edge to edge in the Palais du Louvre. Although Labille-Guiard depicts herself with the tools of her trade, she is hardly dressed for work. Her exquisite portrayal of her sumptuous silk *robe à l'anglaise*, complete with deep décolletage, showcases both her feminine beauty and her mastery of the profession. Two sculptures to the left of the women, barely visible in the shadows, proclaim Labille-Guiard's origins and her character. One is a bust of her father, the clothier Claude-Edme Labille, carved by fellow academician Augustin Pajou, and the other a Vestal Virgin by Jean-Antoine Houdon.[7] There is no need for us to see the canvas Labille-Guiard is painting; her students, one looking on with flushed cheeks and the other casting a knowing glance at the viewer, express the admiration she rightly deserves.

Adélaïde Labille-Guiard

Adélaïde Labille-Guiard (1749–1803)
Self-Portrait with Two Pupils
1785
Oil on canvas
210.8 × 151.1 cm (83 × 59½ in.)
The Metropolitan Museum of Art,
New York

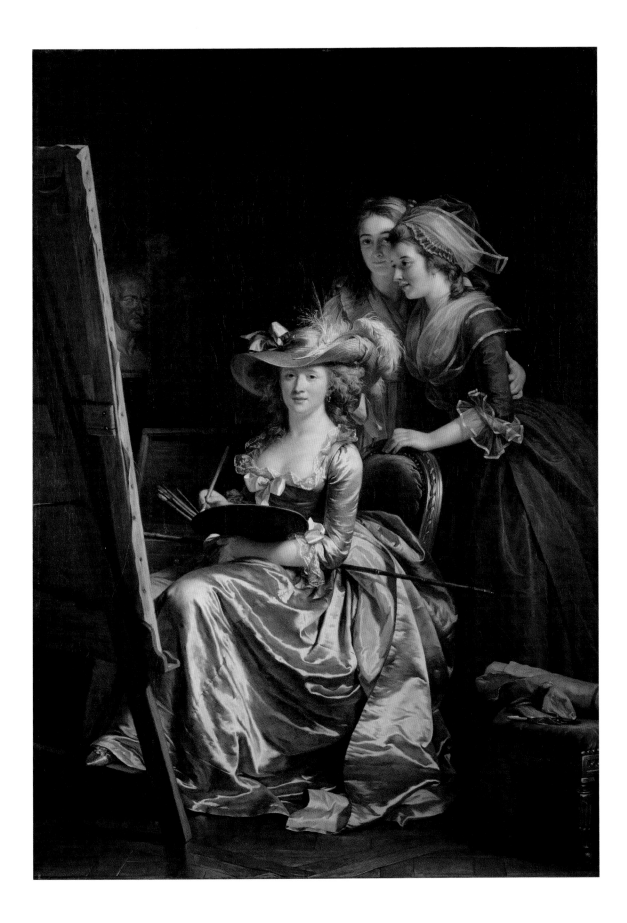

Elisabeth Vigée-Lebrun debuted this self-portrait, in which she holds her six-year-old daughter, Jeanne Julie Louise (known as 'Julie'; 1780–1819), at the Paris Salon of 1787. She had already won acclaim in every sector of the art world, and her reputation as a portraitist was unrivalled. Her confident, natural style of presentation brought her an enviable aristocratic clientele, including Marie Antoinette, the queen of France, with whom she enjoyed a close friendship.[8] Vigée-Lebrun painted subjects from history as well, countering the belief that history painting was a male preserve. In 1783 she became a member of the Académie Royale de Peinture et de Sculpture, a rare honour for a woman, and succeeded in standing out even among that select group. She was the inspiration for the character of an artist in the theatrical production *The Art of Painting* (1779); and a discourse celebrating the talents of women painters, written by the poet Jean-François de La Harpe and read by him at the Académie Française, claimed that her skill outshone that of Rosalba Carriera (page 132), and that her beauty compared favourably to that of Venus.[9]

By choosing to depict herself as a loving – and lovely – mother, Vigée-Lebrun added another admirable dimension to her public identity. Jean-Jacques Rousseau's theories on the innocence of childhood and the maternal responsibility of mothers to cultivate and protect that innocence were widely read among aristocratic women, and with this portrait Vigée-Lebrun presents herself as a model of modern and enlightened maternity. Her warm embrace not only conveys her devotion but also embodies the security her mothering provides. Julie's shy glance at the viewer is calm; she feels at ease in her mother's arms, even though she is not yet ready to venture into the wider world. But the painting also conveys a message about the artist's own sense of security; her fame is such that she need not identify herself as a painter.

Elisabeth Vigée-Lebrun

Elisabeth Vigée-Lebrun (1755–1842)
*Madame Vigée-Lebrun and Her Daughter Julie
(Maternal Tenderness)*
1786
Oil on panel
106 × 84 cm (41¾ × 33⅛ in.)
Musée du Louvre, Paris

As a small child, Rolinda Sharples left England with her parents and crossed the Atlantic to live on the north-eastern coast of the United States. James Sharples (1751/52–1811) and Ellen Wallace Sharples (1769–1849), his third wife, were itinerant portrait painters, and, with the help of James's two sons from his previous marriages, they operated their business out of a large horse-drawn covered wagon. James trained Ellen to assist him. In addition to copying his portraits in pastel, she painted miniatures in watercolour on ivory and embroidered portraits on silk. Ellen, in turn, trained her daughter, and by the age of thirteen Sharples was so adept at capturing a likeness that there was no doubt about her pursuing the family profession. In 1806 Ellen noted in her diary that when her daughter received 'praises', as well as several 'small gold pieces', for drawing a 'young lady of her acquaintance', she applied herself 'with delighted interest, improving rapidly'.[10]

After her father's death in New York, Sharples and her mother returned to England. They established a studio in Bristol, and Sharples gained recognition for lifelike portraits in oil. She worked on a larger scale than either of her parents, and after 1817 she also painted complex narrative compositions, featuring contemporary events, which brought her the attention of the London art world.[11] This self-portrait, with her mother hovering at her side as a kindly mentor and loving muse, conveys Sharples's unequivocal sense of professional identity. She disdains the long-standing convention of presenting another aspect of herself besides 'lady artist' by depicting herself at work at her easel in a studio room densely hung with framed paintings. With a confident smile, Sharples faces the viewer as if looking at her model. Her fashionably elegant – and spotless – attire reflects the social standing that she intended to win through hard work and talent.

Rolinda Sharples (1793/94–1838)
The Artist and Her Mother
c. 1816
Oil on panel
36.8 × 29.2 cm (14½ × 11½ in.)
Bristol Museum and Art Gallery

Rolinda Sharples

Born in the English county of Middlesex, Marie Spartali Stillman had a cosmopolitan background. Her father, Michael Spartali, a wealthy merchant, had served as the Greek consul general in London, and his circle of friends included the art collector and patron Alexander Constantine Ionides. In the 1860s Ionides both supported and socialized with London's cutting-edge artists, and at one of his garden parties Stillman was introduced to Dante Gabriel Rossetti, who invited her to his studio to pose for him. She was a striking young woman, and her slender figure, abundant dark tresses and strong yet soulful features embodied the Pre-Raphaelite ideal. Poet Algernon Swinburne claimed that, on meeting Stillman, he was so ravished by her beauty that he wanted 'to sit down and cry'.[12] Together with Mary Zambaco, her cousin, and Aglaia Coronio, Stillman became known as one of 'the three graces'.

Throughout the 1860s Stillman posed for such artists as Edward Burne-Jones, Julia Margaret Cameron (page 48) and Ford Madox Brown, as well as Rossetti. But she had an ulterior motive: access to these artists' studios gave her the opportunity to observe their techniques. Stillman wanted to be more than an amateur painter or an artist's muse, and in 1864 she began to study painting with Brown. By the time of her marriage to American journalist and artist William Stillman in 1870, she had been exhibiting her work in London for three years.

In this self-portrait, Stillman embodies the aesthetic of sixteenth-century Italian art. She has chosen a Renaissance costume – one she had used for a depiction of Saint Barbara the year before – and she leans on a parapet in the manner associated with the era of Titian. But her source was probably more immediate: Rossetti, too, favoured the bust portrait for his paintings of beautiful women. For Stillman, the pose evoked her Mediterranean heritage, but it also represented her dual role in the art world, as both a beautiful artist's muse and an artist in her own right.[13]

Marie Spartali Stillman

Marie Spartali Stillman (1844–1927)
Self-Portrait
1871
Charcoal and white chalk on paper
63.5 × 51.4 cm (25 × 20¼ in.)
Delaware Art Museum, Wilmington

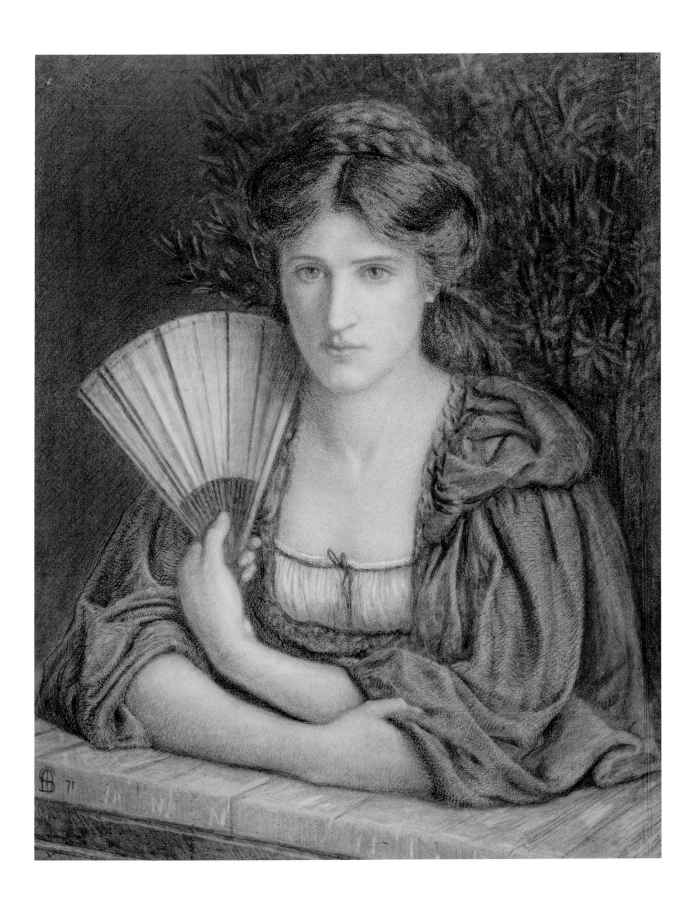

When Leonora Carrington painted this self-portrait, begun in London and completed in Paris, she had long been fascinated by horses. As a child in her native England (she later spent most of her life in Mexico), she had been a keen equestrienne, and the animals can be found in her earliest drawings (*c*. 1929). But the enigmatic portrayal of the two white horses in this painting – the white rocking horse stripped of its mane, and the running horse seen through the window – cannot simply be assigned biographical significance, because Carrington also believed that people possess an instinctive 'inner bestiary', or animal soul.[14]

Carrington wears a rider's jacket and jodhpurs, but her pointed-toe Victorian boots disrupt the purpose of her costume. She has wild hair and a wild look in her eyes, and she is seated on a strangely anthropomorphic parlour chair: the arms have little curled hands, and the feet wear high-heeled shoes. The position of her right hand, with the index finger and little finger extended, is so deliberate that it suggests a ritual gesture, but that gesture cannot be defined. She uses it to point to the oddest presence of all: a prancing hyena with three swollen breasts. A brown mist lingers to the left of the beast, casting a dark shadow on the tile floor, as if some unidentified form is about to take shape.

This portrait marks Carrington's own emergence as a Surrealist. In 1936, after attending the *First International Surrealist Exhibition* at the New Burlington Galleries in London, she began to experiment with dream-like forms, allowing her instinct to guide her imagination. Most of the images in this self-portrait, from the horses of her childhood to the hyena – a creature she believed embodied her own 'insatiable curiosity' – have a link to details of her personal life.[15] As an ensemble, however, they remain cryptic, an expression of instinct and inner consciousness that is sensed rather than understood.

Leonora Carrington

Leonora Carrington (1917–2011)
Self-Portrait (The Inn of the Dawn Horse)
c. 1937–38
Oil on canvas
65 × 81.3 cm (25⅝ × 32 in.)
The Metropolitan Museum of Art,
New York

Dorothea Tanning first encountered Surrealist art when she attended the exhibition *Fantastic Art, Dada, Surrealism* (1936–37) at the Museum of Modern Art in New York. Although she had wanted to study painting since childhood, she had rejected the confines of classroom instruction, convinced that she would learn more on her own. The challenging works that she now admired in the exhibition opened her mind to the 'limitless expanse of possibility'.[16] Over the next few years, while working as an illustrator for Macy's department store, she developed a technique for close observation that was as precise as that of a master of the Northern Renaissance. But she used it to portray the dreamlike imagery of her own subconscious.

As a self-portrait, *Birthday* preserves an accurate likeness of Tanning's delicate and chiselled beauty as a young woman. Her palette blends rich, deep-toned colours – the gold and purple of her brocade jacket and the earthy greenish-brown of her skirt – with an icy opalescence, which shimmers on the painted doors and her ivory skin. But the convincing human and material beauty contrasts with such grotesque, nightmarish details as the tiny, writhing bodies hiding in her overskirt of woven brambles and the winged, hybrid creature that crouches at her bare feet. Her left hand lingers on the knob of an open door, which reveals yet more doors standing ajar. Where they lead cannot be fathomed, but this very uncertainty beckons the viewer to peer through the opening into the ambiguous space. Likewise, the painter's role is mysterious: has she paused before entering herself? Is she a guardian figure? Or is she a siren, luring the unwitting into a labyrinth from which there is no escape? When artist Max Ernst saw the work in Tanning's studio – they met in 1942 and were married four years later – he gave it the title *Birthday*, recognizing in the painting a significant moment in Tanning's emergence as a Surrealist.

Dorothea Tanning

Dorothea Tanning (1910–2012)
Birthday
1942
Oil on canvas
102.2 × 64.8 cm (40¼ × 25½ in.)
Philadelphia Museum of Art

When André Breton described Frida Kahlo as a fellow Surrealist, she noted an essential difference between her work and that of the artists in his circle: 'I never painted dreams, I painted my own reality.'[17] Her rich repertoire of self-portraits reveals that statement to be true. Kahlo first painted her own likeness in 1926, and for the rest of her career she employed her art to interpret the varying dimensions of her experience.

As the child of a German Jew (her father) and a Spanish-Mexican Catholic (her mother), Kahlo had always embraced her mixed heritage. When she married Mexican artist Diego Rivera in 1929, however, she emphasized her *Mexicanidad* ('Mexican-ness'), employing an idiosyncratic display of traditional garments, hairstyles and jewellery to express her ethnic identity. She painted *The Two Fridas* at a significant moment in her life: after a trip to Paris to participate in an exhibition organized by Breton, she and Rivera separated. Here, by representing her ancestry as a dyad, Kahlo affirms that it is her duality – not her partner – that defines who she is.

On the left, Kahlo depicts herself in an old-fashioned, European-style bridal gown. On the right, she wears an example of the traditional dress worn by the women of the Tehuana region of Mexico: a square-shouldered, short-sleeved *huipil*. In face and figure, the two Fridas are one, and they clasp hands to emphasize their unity. They are further entwined by shared blood vessels, which lead from their exposed hearts and curl around their arms and shoulders. One thin red tendril can be traced to a miniature, bearing Rivera's image, in Mexican Frida's left hand. European Frida snips the end of another blood vessel with a pair of surgical scissors, spattering her white skirt with the co-mingled blood in patterns that resemble the flowers on the embroidered hem. The indelible stain bears permanent witness to the unity of Kahlo's being, no matter if other relationships are severed.

Frida Kahlo

Frida Kahlo (1907–1954)
The Two Fridas
1939
Oil on canvas
172 × 172 cm (67¾ × 67¾ in.)
Museo de Arte Moderno, Mexico City

Elizabeth Peyton does not regard the likenesses that she paints as portraits; rather, she describes them as 'pictures of people'.[18] Her interest in depicting people can be traced back to her days as a student at New York's School of Visual Arts (1984–87), where she invented portraits for the characters she read about in nineteenth-century novels. She was equally inventive with her medium, painting her images on panes of glass, which made the images more luminous but less substantial than if they had been painted on a more conventional type of support. Echoes of this translucent effect can be seen in the way in which light seems to emanate from the pigment that she deftly applies to canvas or board.

When creating her 'pictures', Peyton often works from a photograph she has taken of her sitter, rather than working from life.[19] But when she depicts herself, she prefers to have someone else take the photograph. To Peyton, the act of standing in front of a mirror, with a camera or brush in hand, seems 'too contrived'.[20] This self-portrait was based on a photograph taken by the artist Tony Just. It conveys the intimacy of their relationship, as well as an almost casual spontaneity, as if Peyton were unaware that Just had taken her picture. These layers of remove allow Peyton to portray herself as she portrays others: deliberately straightforward and uncritical, simulating the experience of a quick glance in real life. She appears in her 'picture' fully absorbed in her reading, exactly as she would focus on the act of painting her own picture. Peyton seems to have stepped outside herself to represent her own image. Whether they depict a friend, a historical character, a celebrity in the news, or the artist herself, Peyton's pictures of people feel authentic, even though she has calculated every aspect of the composition.

Elizabeth Peyton

Elizabeth Peyton (born 1965)
E.P. Reading (Self-Portrait)
2005
Oil on board
25.4 × 20.3 cm (10 × 8 in.)
Collection of David Teiger

Notes

INTRODUCTION

1 Anna Mary Howitt, letter to Barbara Bodichon, quoted in Deborah Cherry, *Painting Women: Victorian Women Artists*, London and New York (Routledge) 1993, p. 56. Cherry suggests that the letter was written around 1848; it must, however, have been written before 1850, when Howitt left London to study painting in Munich. The italics are Howitt's.

2 See 'Danger', *Oxford Dictionaries*, oxforddictionaries.com/definition/danger, accessed 5 April 2012.

3 Giovanni Boccaccio, quoted in Whitney Chadwick, *Women, Art, and Society*, 4th edn, London (Thames & Hudson) 2007, p. 35.

4 See Julia K. Dabbs, *Life Stories of Women Artists, 1550–1800: An Anthology*, Farnham (Ashgate) 2009, pp. 34–35. Dabbs notes (p. 34 n. 27) that while the Latin manuscripts mention the hand-held mirror, the Italian version she translates in her anthology says that viewers of the portrait were struck by its natural appearance when they looked at it in a mirror.

5 Giorgio Vasari, *Lives of the Most Eminent Painters, Sculptors and Architects* [2nd edn, 1568], 10 vols, trans. Gaston du C. De Vere, London (Macmillan and The Medici Society) 1912–15, vol. 5, p. 125.

6 For example, 'I, the maiden Sofonisba, equalled the Muses and Apelles in performing songs and handling my colours.' Quoted in Frances Borzello, *Seeing Ourselves: Women's Self-Portraits*, New York (Harry N. Abrams) 1998, p. 46. According to Borzello, the inscription appears on a self-portrait of Anguissola painting a Virgin and Child (similar to the work shown on page 131 of this book), now in the Zeri Collection in Mentana, Italy. Apelles was a renowned Greek painter of the fourth century BC. Although none of his works have survived, stories of his astonishing accomplishments have lent him iconic significance.

7 Dabbs, *Life Stories of Women Artists*, pp. 34–35.

8 *Self-Portrait with Small Statues* (1579), Galleria degli Uffizi, Florence.

9 Mariya Bashkirtseva, diary entry, 5 October 1877, in *Marie Bashkirtseff: The Journal of a Young Artist 1860–1884*, trans. Mary J. Serrano, New York (E.P. Dutton) 1926, p. 162. Both the spelling of Bashkirtseva's name and the date

of her birth vary between sources; the dates in the title of this work refer to life dates rather than the chronology of the journal.

10 Judy Chicago, 'Introduction', in Judy Chicago and Edward Lucie-Smith, *Women and Art: Contested Territory*, New York (Watson-Guptill) 2000, p. 8.

11 Sylvia Sleigh, interview given at the opening of the exhibition *WACK! Art and the Feminist Revolution* at the Geffen Contemporary at MOCA, Los Angeles, 4 March 2007, available online at moca.org/wack/?p=187, accessed 18 March 2012.

12 Andrew Graham-Dixon, 'This is the House that Rachel Built', *The Independent*, 2 November 1993. *House* won Whiteread the Turner Prize in 1993, the first time it had been awarded to a woman.

13 Guerrilla Girls, *Confessions of the Guerrilla Girls*, New York (HarperCollins) 1995, p. 53.

14 The exhibition ran from 14 March to 31 May 2010.

15 See Judith Thurman, 'Walking Through Walls: Marina Abramovic's Performance Art', *The New Yorker*, 8 March 2010, pp. 24–30.

16 See *Marina Abramovic: The Artist is Present*, exhib. cat. by Klaus Biesenbach, New York, The Museum of Modern Art, March–May 2010, p. 138.

17 So many people had this response that a website was created called 'Marina Made Me Cry'; see http://marinaabramovicmademecry.tumblr.com, accessed 19 March 2012. I am grateful to Lindsay J. Bosch for bringing this to my attention.

18 Arthur C. Danto, 'Sitting with Marina', *New York Times*, 23 May 2010, http://opinionator.blogs.nytimes.com/2010/05/23/sitting-with-marina, accessed 19 March 2012.

IN THE COMPANY OF MEN

1 Giorgio Vasari, *Lives of the Most Eminent Painters, Sculptors and Architects* [2nd edn, 1568], 10 vols, trans. Gaston du C. De Vere, London (Macmillan and The Medici Society) 1912–15, vol. 9, p. 155.

2 The painting has long been known as *The Proposition*, but recent scholarship suggests a more nuanced interpretation, as outlined here. See Cynthia Kortenhorst-von

Bogendorf Rupprath's explanation in *Judith Leyster: A Dutch Master and Her World*, exhib. cat. by J.A. Welu *et al.*, Haarlem, Frans Hals Museum, May–August 1993; Worcester Art Museum, Mass., September–December 1993, p. 168.

3 Anonymous, quoted in *ibid*. Cats's book is titled *Spiegel van den ouden ende nieuwen tijdt* (Mirror of old and new times). Although published in 1632, one year after Leyster completed her painting, it includes common sayings long known throughout The Netherlands.

4 Giovanni Gherardo de Rossi, *Vita di Angelica Kauffman, pittrice* (1810), quoted in Angela Rosenthal, *Angelica Kauffman: Art and Sensibility*, New Haven, Conn., and London (Yale University Press for the Paul Mellon Centre for Studies in British Art) 2006, p. 272.

5 This is the second of two known versions of the work; the first, held by the Pushkin Museum in Moscow, was painted in Rome between 1791 and 1792. See *ibid*., pp. 271–72. It was common practice in this era for artists to replicate their own paintings for sale, for gifts or even for studio records.

6 William Rossetti, 'Art News from England – No. 5', *The Crayon*, 2, 22 August 1855, p. 118.

7 Saint-Simonianism, based on the writings of the French social reformer Claude Henri de Rouvroy, comte de Saint-Simon (1760–1825), advocated a social reorganization that, among other things, assigned greater power to artists and women than they possessed at the time.

8 Queen Victoria expressed her admiration in a letter to Bonheur, who had hoped that the queen would purchase the painting for the Royal Collection. See Gabriel P. Weisberg, 'Rosa Bonheur's Reception in England and America', in *Rosa Bonheur: All Nature's Children*, exhib. cat. by Gabriel P. Weisberg *et al.*, Bordeaux, Barbizon and New York, 1997–98, p. 8.

9 In 1873 Simeon was arrested on a charge of solicitation and sodomy in a public urinal. The humiliation wrecked his career, and his retreat into alcohol ruined his health. The scandal also cast a shadow on Solomon's working life. She continued to paint, but rarely exhibited.

10 This comment was made in reference to *Peg Woffington's Visit to Triplet*, exhibited at the Royal

Academy of Arts in 1860. *The Art-Journal*, 66, June 1860, p. 168.

11 Albert Wolff, *Le Figaro*, 3 April 1876, quoted in John Rewald, *The History of Impressionism*, 4th edn, New York (The Museum of Modern Art) 1973, p. 368. Rewald cites anecdotal evidence that Wolff demanded a refund following his visit to the exhibition, and that, after reading Wolff's scathing review, Morisot's husband, Eugène Manet, wanted to challenge the critic to a duel.

12 After the birth of her daughter, Julie, in 1878, Morisot experienced a period of poor health that impeded her work in the studio. She declined to participate in the fourth Impressionist exhibition, held in 1879, feeling that she had nothing new to show. Her participation in the other seven exhibitions extended beyond submitting works for display: she always took an active role in their organization and promotion.

13 There is much discussion – and confusion – about exactly when and how Claudel came to know Rodin. See *Camille Claudel and Rodin: Fateful Encounter*, exhib. cat. by Odile Ayral-Clause *et al.*, Quebec, Detroit and Martigny, 2005–2006, pp. 38–41. It had commonly been thought that she had modelled for him prior to their encounter at the women's atelier, but current scholars question this assumption. Claudel seems to have organized the atelier with several classmates from the Académie Colarossi. Their regular tutor, Alfred Boucher (1850–1934), had left Paris for Florence and asked Rodin to take over.

14 Jules Dubois to Mathias Morhardt, in 'Mlle Claudel', *Mercure de France*, March 1898, quoted in *ibid*., p. 57.

15 Georgia O'Keeffe, letter to Henry McBride, summer 1929, quoted in Lisa Mintz Messinger, *Georgia O'Keeffe*, London (Thames & Hudson) 2001, p. 106.

16 Georgia O'Keeffe, 'I Can't Sing So I Paint! Miss O'Keeffe Explains the Subjective Aspect of Her Work', *New York Sun*, 5 December 1922, quoted in *ibid*., p. 45.

17 O'Keeffe purchased Rancho de los Burros and 2.8 hectares (7 acres) of land from Arthur Newton Pack, owner of Ghost Ranch and co-founder of the American Nature Association. In 1945 she bought a hacienda in Abiquiu, New Mexico, retaining Rancho de los Burros as her summer and autumn residence.

18 Lee Krasner, statement for unpublished catalogue, 19 January 1979, quoted in Gail Levin, *Lee Krasner: A Biography*, New York (HarperCollins) 2011, p. 419.

19 G.T. [Gretchen T. Monson], 'Man and Wife', *Art News*, October 1949, p. 45. In addition to Krasner and Pollock, the nine featured couples included Dorothea Tanning and Max Ernst, Elaine de Kooning and Willem de Kooning, and Françoise Gilot and Pablo Picasso.

BLURRING BOUNDARIES

1 H. Colin Slim, 'Tintoretto's Music-Making Women at Dresden', *Imago Musicae*, 4, Fall 1987, p. 47.

2 Carlo Ridolfi, *The Life of Tintoretto, and of His Children Domenico and Marietta* [1648], trans. Catherine Enggass and Robert Enggass, University Park, Pa. (University of Pennsylvania Press) 1984, p. 98.

3 Paintings inspired by Robusti's life include Léon Cogniet's *Tintoretto Painting His Dead Daughter* (1843) and Philippe-Auguste Jeanron's *Tintoretto and His Daughter* (1857). George Sand featured her in the novel *Les Maîtres Mosaïstes* (1838), and Luigi Marta fictionalized her life in the play *Tintoretto and His Daughter* (1845).

4 Maria Sibylla Merian, 'Preface', *Metamorphosis insectorum Surinamensium* (1705), quoted in Natalie Zemon Davis, *Women on the Margins: Three Seventeenth-Century Lives*, Cambridge, Mass. (Harvard University Press) 1995, p. 143.

5 Maria Sibylla Merian, quoted in Katharina Schmidt-Loske, *Insects of Surinam*, Cologne (Taschen) 2009, p. 15.

6 Merian married Johann Andreas Graff, one of her stepfather's pupils, in 1665. She left him in 1685 to join the Labadists, a utopian Protestant community, and divorced him before leaving for Suriname.

7 Barbara Leigh Smith, letter to Bessie Parkes, May 1854, quoted in *Elizabeth Siddal, 1829–1862: Pre-Raphaelite Artist*, exhib. cat. by Jan Marsh, Sheffield, The Ruskin Gallery, 1991, p. 13; 'PRBs' refers to members of the Pre-Raphaelite Brotherhood. Although a skilled painter, Smith is better known as an activist for women's rights under her married name, Barbara Bodichon.

8 Christina Rossetti, 'In an Artist's Studio', in *New Poems, Hitherto Unpublished or Collected*, ed. William Michael Rossetti, London and New York (Macmillan) 1896, p. 114.

9 Julia Norman, letter to Julia Margaret Cameron, *c.* December 1863, quoted in *Julia Margaret Cameron: The Complete Photographs*, exhib. cat. by Julian Cox and Colin Ford, Los Angeles, The J. Paul Getty Museum; Bradford, National Media Museum, 2003, p. 24.

10 Julia Margaret Cameron, letter to John Herschel, 31 December 1864, quoted in *ibid.*, p. 41.

11 Liddell posed repeatedly for Cameron during the late summer and early autumn of 1872. In addition to being the subject of several portraits, she posed in character as Ceres, Aletheia, St Agnes and one of Lear's daughters, with her sisters as the other daughters and Cameron's husband as the old king.

12 Guillaume Apollinaire, 'Les Réformateurs des costume', *Mercure de France*, January 1914, quoted in *Sonia Delaunay: Fashion and Fabrics*, London (Thames & Hudson) 1991, p. 113.

13 Unnamed author, quoted in *ibid.*, p. 69.

14 Unnamed author, quoted in N. Iqbal Singh, *Amrita Sher-Gil: A Biography*, New Delhi (Vikas) 1984, p. 25. I am grateful to Vrinda Agrawal for calling Amrita Sher-Gil's work to my attention, and for her contribution to this entry.

15 Amrita Sher-Gil, letter to Karl Khandalavala, April 1938, in Amrita Sher-Gil, *A Self-Portrait in Letters and Writings*, 2 vols, ed. Vivan Sundaram, New Delhi (Tulika Books) 2010, vol. 2, p. 491.

16 Bridget Riley, quoted in *Modern Women: Women Artists at the Museum of Modern Art*, exhib. cat., ed. Cornelia H. Butler and Alexandra Schwartz, New York, The Museum of Modern Art, 2010, p. 256.

17 Bridget Riley, quoted in *Bridget Riley Retrospective*, exhib. cat. by Anne Montfort *et al.*, Musée d'Art Moderne de la Ville de Paris, June–September 2008, p. 24.

18 Originally, the works were not titled, because Sherman did not want to spoil the ambiguity of the images. The series title *Untitled Film Stills* was added in 1980 by Metro Pictures gallery in New York. The numbers, also added by the gallery, were intended to establish the order in which the works were made, but Sherman says that the sequence has been mixed up, and that the numbers now serve merely to identify the individual images. See *Cindy Sherman: The Complete Untitled Film Stills*, ed. David Frankel, New York (The Museum of Modern Art) 2003, p. 7.

19 For the sequence of these sketches, see *Paula Rego*, exhib. cat. by Fiona Bradley *et al.*, Tate Liverpool, February–April 1997; Lisbon, Centro Cultural de Belém, May–August 1997, pp. 133–34.

20 Candida Höfer, quoted in 'Candida Höfer', Museum of Contemporary Photography, Columbia College, Chicago, mocp.org/collections/permanent/hfer_candida.php, accessed 21 November 2011.

21 Candida Höfer, interview with Carolyn Yerkes, *Museo Magazine*, 2010, museomagazine.com/802470/candida-h-fer, accessed 20 November 2011.

22 This anecdote is frequently cited as the origin of the series *Splendour of the Medici*, but a date for the visit to the Uffizi is never specified. See, for example, *Pulp Fashion: The Art of Isabelle de Borchgrave*, exhib. cat. by Jill D'Alessandro, San Francisco, Legion of Honor, February–June 2011, p. 63.

23 Isabelle de Borchgrave, quoted in *ibid.*

LOOKING AT BODIES

1 *The Vision of Saint Hyacinth* (1599) was commissioned by Girolamo Bernerio, Cardinal of Ascoli, for his chapel in Santa Sabina. It is believed to be Fontana's last important work completed in Bologna. See Caroline P. Murphy, *Lavinia Fontana: A Painter and Her Patrons in Sixteenth-Century Bologna*, New Haven, Conn., and London (Yale University Press) 2003, p. 195.

2 Louise Jopling, *Twenty Years of My Life, 1867–1887*, London (John Lane) 1925, p. 3. Jopling, a British aspiring artist and young mother residing in Paris, took lessons in Chaplin's studio in 1867.

3 Women were not admitted into the École des Beaux-Arts until 1896. At Julian's academy, both the men's and the women's programme were a success. Julian opened additional studios for women, and continued as head of the academy until his death.

4 Mariya Bashkirtseva, diary entry, 2 October 1877, in *Marie Bashkirtseff: The Journal of a Young Artist 1860–1884*, trans. Mary J. Serrano, New York (E.P. Dutton) 1926, p. 161.

5 Mariya Bashkirtseva, diary entry, 1 November 1880, in *ibid.*, p. 245.

6 This was particularly appropriate. During her first trip to Paris, in 1898, John had studied at Whistler's Parisian school, the Académie Carmen. *Muse* is in the collection of the Musée d'Orsay in Paris.

7 Gwen John, quoted in *Gwen John: An Interior Life*, exhib. cat. by Cecily Langdale and David Fraser Jenkins, London, Manchester and New Haven, 1985–86, p. 83. *Nude Girl* (1909–10) is in the Tate Collection, London. To be precise, the girl is not nude; rather, her dress is pulled down to her thighs. Both paintings are almost exactly the same size, suggesting a close conceptual relationship.

8 'NEAC Retrospective', *The Athenaeum*, 3, 1925, p. 8. The unnamed critic was reviewing an exhibition at the New English Art Club (NEAC) in London.

9 Rebecca Horn, interview with Germano Celant, in *Rebecca Horn*, exhib. cat. by Germano Celant *et al.*, New York, Eindhoven, Berlin, Vienna, London and Grenoble, 1993–95, p. 15.

10 Rebecca Horn, quoted in *Rebecca Horn: The Glance of Infinity*, exhib. cat., ed. Carl Haenlein, Hannover, Kestner Gesellschaft, May–July 1997, p. 50.

11 Alice Neel, quoted in Patricia Hills, *Alice Neel*, New York (Harry N. Abrams) 1983, pp. 189–90.

12 Valerie Solanas, a radical feminist, shot Warhol in the chest in 1968, claiming that he was trying to steal her work. She was charged with attempted murder, and Warhol remained fearful that she would attack him again. Neel's portrait of Warhol is held by the Whitney Museum of American Art in New York.

13 Alice Neel, quoted by Benny Andrews during a group discussion moderated by Ann Temkin, Philadelphia Museum of Art, 6 April 1999; see *Alice Neel*, exhib. cat., ed. Ann Temkin, New York, Whitney Museum of American Art, then travelling, 2000–2001, p. 73. Andrews posed for Neel with his wife, Mary Ellen, in 1972.

14 Jenny Saville, quoted in David Sylvester, 'Areas of Flesh', in John Gray *et al.*, *Jenny Saville*, New York (Rizzoli) 2005, p. 14.

15 *Ibid.*

16 Vanessa Beecroft, interview by Massimillian Gioni, quoted in Helena Kontova and Massimillian Gioni, 'Vanessa Beecroft', *Flash Art*, 36, January–February 2003,

reprinted in *Flash Art* (International Edition), 41, July–September 2008, p. 211. Beecroft was responding to the following question: 'You talk about these girls as though they were objects. What are these girls to you?'

17 See, for example, Judith Thurman, 'The Wolf at the Door: Vanessa Beecroft's Provocative Art is Inextricably Tied to Her Obsession with Food', *The New Yorker*, 17 March 2003, pp. 114–23.

18 See C. Campbell, 'Vanessa Beecroft' [interview with Vanessa Beecroft and Pietra Brettkelly], *Flash Art* (International Edition), 41, March–April 2008, p. 96. The performance *VB39* (1999; Museum of Contemporary Art San Diego) featured US Navy SEALs, while *VB65* (2009; Padiglione d'Arte Contemporanea, Milan), also known as *Last Supper*, consisted of twenty-four African immigrants, dressed in vintage-style dinner jackets and suits by designer Martin Margiela, eating roast chicken at a long table.

SEIZING THE NARRATIVE

1 The second half of the proverb reads, 'the poverty of the poor is their ruin'. *The New Oxford Annotated Bible*, ed. Herbert G. May and Bruce M. Metzger, New York (Oxford University Press) 1973, p. 780. The subtitle appeared in the catalogue for the Royal Academy exhibition.

2 It is worth noting that Osborn did enjoy some success in her chosen profession. She exhibited several times at the Royal Academy, her work attracted modest but popular notice, and one of her paintings, *The Governess* (1860), was purchased by Queen Victoria.

3 John Ruskin, 'Academy Notes' [1875], in Edward Cook and Alexander Wedderburn, eds, *The Works of John Ruskin*, 39 vols, London (George Allen) 1903–12, vol. 14, p. 308.

4 *Ibid*. In her memoir, Thompson acknowledged Ruskin's praise, confessing, 'I was very pleased to see myself in the character of an Amazon.' Elizabeth Butler, *An Autobiography*, Boston (Houghton Mifflin) 1923, p. 146.

5 Sir William Butler (1838–1910) had a highly distinguished military career, rising to the rank of lieutenant general in 1900.

6 Lail Gay, 'Edmonia Lewis: The Colored Sculptress' [1876], and J.S. Ingram, *The Centennial Exposition Described and Illustrated* [1876], quoted in Kirsten Pai Buick, *Child of the Fire: Mary Edmonia Lewis and the Problem of Art History's Black and Indian Subject*, Durham, NC (Duke University Press) 2010, p. 199. The American section included 152 works.

7 Lewis often gave contradictory information about her childhood, exaggerating her exposure to Native American culture and giving her year of birth as, variously, 1844, 1845 and 1854. See *ibid.*, pp. 8–10.

8 William Clark Jr, *Great American Sculptures*, Philadelphia (Gebbie & Barrie) 1878, p. 141. Clark viewed the work in 1878 at the Chicago Interstate Exposition.

9 For Goncharova's theories of 'West' and 'East', see Nika Levando, 'Natalia Goncharova and the Ballets Russes', MA thesis, School of the Art Institute of Chicago, Department of Art History, Theory and Criticism, 2010, chap. 1, pp. 5–7.

10 These references are based on Chicago's own description of the work. See Judy Chicago, *The Dinner Party: From Creation to Preservation*, London and New York (Merrell) 2007, p. 201.

11 Louise Bourgeois, 'Ode to My Mother' [1995], in *Louise Bourgeois*, exhib. cat. by Frances Morris, London, Tate Modern, May–December 2000, p. 65.

12 Louise Bourgeois, quoted in *ibid.*, p. 50.

13 Louise Bourgeois, interview with Cheryl Kaplan, 2004, quoted in *Louise Bourgeois*, exhib. cat., ed. Frances Morris, London, Paris, New York, Los Angeles and Washington, D.C., 2007–2009, p. 130.

14 Louise Bourgeois, interview with Cecilia Blomberg, 1998, quoted in *ibid.*, p. 272.

15 Kara Walker, quoted in *Kara Walker: Deutsche Bank Collection*, exhib. cat. by Ariane Grigoteit *et al.*, Berlin, Deutsche Guggenheim, 2002, p. 55.

16 Walker cites as her inspiration the Atlanta Cyclorama, a 109-metre-long (358 feet) depiction of the Battle of Atlanta (1864), which she describes as 'history painting gone nuts'. See *Kara Walker: Slavery! Slavery!*, exhib. cat. by Robert Hobbs, 25th International Biennial of São Paulo, March–June 2002, p. 27.

17 The full title is *Slavery! Slavery! Presenting a GRAND and LIFELIKE Panoramic Journey into Picturesque Southern Slavery or 'Life at "Ol'Virginny's Hole" (sketches from Plantation Life)' See the Peculiar Institution as never before! All cut from black paper by the able hand of Kara Elizabeth Walker, an Emancipated Negress and leader in her Cause.*

18 In 1997 Betye Saar started a letter-writing campaign to block the exhibition of Walker's work. Others, including Howardina Pindell, also questioned her intentions, feeling that she was mocking the Civil Rights struggle and pandering to white prejudice. But Henry Louis Gates Jr defended her right as an artist to use whatever imagery she wished in her assault on stereotypical thinking, observing that no one could mistake her depictions for a realistic account of history. For a summary of the debate, see Hilton Als, 'The Shadow Act: Kara Walker's Vision', *The New Yorker*, 8 October 2007, pp. 76–77.

19 Shirin Neshat, quoted in Shadi Sheybani, 'Women of Allah: A Conversation with Shirin Neshat', *Michigan Quarterly Review*, 38, Spring 1999, pp. 204–16, available online at http://quod.lib.umich.edu/cgi/t/text/text-idx?cc=mqr;c=mqr;c=mqrarchive;idno=act2080.0038.207;rgn=main;view=text;xc=1;g=mqrg, accessed 29 November 2011.

20 For Neshat's own words, see 'Shirin Neshat, *Speechless*, 1996', MoMA Multimedia, moma.org/explore/multimedia/audios/27/652, accessed 30 November 2011.

21 Kiki Smith, interview with Wendy Weitman, 16 December 2002, quoted in *Kiki Smith: Prints, Books and Things*, exhib. cat. by Wendy Weitman, New York, The Museum of Modern Art, December 2003 – March 2004, p. 14.

PLAYING WITH DANGER

1 The exact date of Gentileschi's arrival in Florence is unknown. *Judith and Her Maidservant*, dated between 1618 and 1619, is believed to be the first major work she produced in the city. See Mary D. Garrard, *Artemisia Gentileschi: The Image of the Female Hero in Italian Baroque Art*, Princeton, NJ (Princeton University Press) 1989, p. 39. She remained in Florence until 1620.

2 Gentileschi painted at least five works based on Judith's story, making it the most dominant theme in her œuvre. See *ibid.*, p. 278.

3 This anecdote is attributed to Oppenheim and widely repeated, but without verification. See, for example, the account in *Meret Oppenheim: Beyond the Teacup*, exhib. cat. by Jacqueline Burckhardt and Bice Curiger, New York, Solomon R. Guggenheim Museum, June–October 1996, p. 161.

4 Among Catlett's concerns were the anti-communist investigations of the House Committee on Un-American Activities (1938–75), which ruined the careers and damaged the reputations of many who shared her beliefs. A permanent resident of Mexico from 1947, Catlett applied for and obtained citizenship in 1962, after which she was declared an 'undesirable alien' by the United States and barred from visiting until 1974.

5 Elizabeth Catlett, quoted in Samella Lewis, *The Art of Elizabeth Catlett*, Claremont, Calif. (Hancraft Studios) 1984, p. 17.

6 In its celebration of women's strength in the face of adversity, *The Negro Woman* features such legendary figures as the abolitionists Harriet Tubman and Sojourner Truth, as well as anonymous domestic workers, teachers and community organizers.

7 Marina Abramovic, quoted in *Marina Abramovic: The Artist is Present*, exhib. cat. by Klaus Biesenbach, New York, The Museum of Modern Art, March–May 2010, p. 90.

8 For example, Stout recalls that when a spoon was dropped in a certain way, her grandmother would not pick it up herself. Or, if someone had a haircut in the house, her grandmother would burn the clippings. No one ever explained why; it was just what they did. See *Astonishment and Power*, exhib. cat. by Wyatt MacGaffey and Michael D. Harris, Washington, D.C., National Museum of African Art, April–January 1994, p. 114.

9 For a full discussion of *nkisi* figures and their use, see *Africa: The Art of a Continent*, exhib. cat., ed. Tom Phillips, London, Royal Academy of Arts, October 1995 – January 1996, p. 246.

10 Renée Stout, interview with Lindsay J. Bosch and Debra N. Mancoff, 14 January 2009.

11 Guerrilla Girls, *Confessions of the Guerrilla Girls*, New York (HarperCollins) 1995, p. 61.

12 Following the PAF's decision not to use the design, the Guerrilla Girls paid to exhibit the poster on the side of buses, but it was only

a brief run: the arrangement was cancelled on the basis of the image being 'too suggestive'. Over the years they have reissued the poster in varying formats, and have documented instances in which the poster was tagged with graffiti. See *ibid.*, pp. 60–61.

13 The group has had a remarkable history of maintaining anonymity for its members. The exact number of members is unknown, but in 2000 the group experienced what they described as the 'banana split', which involved a breakaway group dedicated to confronting discrimination in the theatre. In 2003 two of the original members filed a lawsuit against this group, as well as an online entity using the Guerrilla Girls name, and had to reveal their true identities in court: 'Frida Kahlo' and 'Käthe Kollwitz' are now known to be Jerilea Zempel and Erika Rothenberg, respectively. See Jeffrey Toobin, 'Girls Behaving Badly', *The New Yorker*, 30 May 2005, pp. 34–35.

14 Catherine Opie, from a lecture given at the Solomon R. Guggenheim Museum, New York, 19 October 2005, quoted in *Catherine Opie: American Photographer*, exhib. cat. by Jennifer Blessing and Nat Trotman, New York, Solomon R. Guggenheim Museum, September 2008 – January 2009, p. 11. Opie spent her childhood in Sandusky, Ohio.

15 Catherine Opie, interview with Kristine McKenna, 'Welcome to Opie's World', *Los Angeles Times*, 26 June 1994, quoted in *ibid.*, p. 52.

16 Catherine Opie, interview with Russell Ferguson, 1996, quoted in *Catherine Opie*, exhib. cat. by Kate Bush *et al.*, London, The Photographers' Gallery, August–September 2000; Chicago, Museum of Contemporary Art, November 2000 – February 2001, p. 44.

17 Cox's other alter ego is 'Raje', a female superhero who liberates stereotypes used in advertising and popular media. See, for example, *The Liberation of Aunt Jemima and Uncle Ben* (1998), http://reneecox.org, accessed 28 November 2011.

18 For more on the exchange, see Monte Williams, '"Yo Mama" Artist Takes on Catholic Critic', *New York Times*, 21 February 2001, available online at nytimes.com/2001/02/21/nyregion/yo-mama-artist-takes-on-catholic-critic.html, accessed 26 November 2011.

19 For a summary of the press reaction, see Deborah Cherry, 'Tracey Emin's *My Bed*', The European Graduate School, egs.edu/faculty/tracey-emin/articles/tracey-emins-my-bed, accessed 7 November 2011. The extensive media coverage attracted an unprecedented 140,000 visitors over the course of the three-month exhibition at the Tate. Emin got the attention, but video artist Steve McQueen was awarded the prize.

20 Tracey Emin, interview with *The Big Issue*, October 1999, quoted in 'The Turner Prize: Year by Year: 1999', tate.org.uk/britain/turnerprize/history/1999.shtm, accessed 8 November 2011.

IN HER OWN IMAGE

1 At least fourteen have been identified, the largest known number of self-portraits for any artist between the time of Albrecht Dürer (1471–1528) and Rembrandt (1606–1669).

2 For more on this enigmatic dual portrait, see Mary D. Garrard, 'Here's Looking at Me: Sofonisba Anguissola and the Problem of the Woman Artist', in Norma Broude and Mary D. Garrard, eds, *Reclaiming Female Agency: Feminist Art History After Postmodernism*, Berkeley, Calif. (University of California Press) 2005, pp. 27–47.

3 This particular portrait was newly discovered and added to the list of Anguissola's firmly attributed works in time for an exhibition at the National Museum of Women in the Arts, Washington, D.C., held in 1995. See *Sofonisba Anguissola: Renaissance Woman*, exhib. cat. by Sylvia Ferino-Pagden, Washington, D.C., National Museum of Women in the Arts, April–June 1995, p. 24.

4 Frances Borzello, *Seeing Ourselves: Women's Self-Portraits*, New York (Harry N. Abrams) 1998, p. 71.

5 Carriera's royal clients included Frederick IV, King of Demark and Norway; August III, Elector of Saxony and King of Poland; and, in Vienna, Charles VI, Holy Roman Emperor.

6 Labille-Guiard was admitted to the Académie with Elisabeth Vigée-Lebrun (see page 136 of this book); Anne Vallayer-Coster and Marie-Thérèse Reboul were already *académiciennes*. Shortly afterwards, Charles-Claude Flahaut de la Billaderie, comte d'Angiviller and director of the Bâtiments du Roi, petitioned for and obtained a royal

decree limiting the number of *académiciennes* to four. See Laura Auricchio, *Adélaïde Labille-Guiard: Artist in the Age of Revolution*, Los Angeles (J. Paul Getty Museum) 2009, p. 29.

7 Pajou's sculpture was also on display at the Salon of 1785, in the same gallery. Labille-Guiard, no doubt, was inviting comparison. Her father ran an exclusive clothes shop for women on the rue Neuve des Petits-Champs.

8 Sources differ as to when Vigée-Lebrun first painted Marie Antoinette, but it was probably in either 1778 or 1779. It is estimated that she painted between twenty-five and thirty portraits of the queen and her children.

9 For more on the theatrical production, see Frances Borzello, *A World of Our Own: Women as Artists Since the Renaissance*, New York (Watson-Guptill) 2000, p. 121. La Harpe's discourse is quoted in Mary D. Sheriff, *The Exceptional Woman: Elisabeth Vigée-Lebrun and the Cultural Politics of Art*, Chicago and London (University of Chicago Press) 1996, p. 40.

10 Ellen Wallace Sharples, diary entry, 1806, quoted in Kathryn Metz, 'Ellen and Rolinda Sharples: Mother and Daughter Painters', *Woman's Art Journal*, 16, Spring–Summer 1995, p. 3.

11 Sharples exhibited at the Royal Academy of Arts in London in 1820, 1822 and 1824. In 1825 she switched her allegiance to the newly founded Society of British Artists, exhibiting with them eight times between 1825 and 1836. In 1827 the all-male group made Sharples an honorary member.

12 Algernon Swinburne, quoted in W. Graham Robertson, *Life Was Worth Living*, New York (Harper and Brothers) 1931, p. 13.

13 Stillman returned to *Self-Portrait* in 1874, replicating it in watercolour. The new version (current location unknown) softened and generalized her strong, distinctive features, but won the admiration of Henry James, who noted that she was 'extremely beautiful', and praised the 'refinement' and 'deep pictorial sentiment' of the work as being of a 'singular intensity'. Henry James, 'Art', *Atlantic Monthly*, 35, January 1875, p. 119.

14 Leonora Carrington, quoted by Marina Warner in her introduction to Leonora Carrington, *The House of Fear: Notes from Down Below*, trans. Kathrine Talbot and Marina Warner, New York (E.P. Dutton)

1988, p. 1. Warner attributes Carrington's belief to her embrace of the indigenous culture of her adopted homeland, Mexico, where she lived from 1942.

15 Leonora Carrington, interview, 1999, quoted in Susan L. Aberth, *Leonora Carrington: Surrealism, Alchemy and Art*, Farnham, Surrey (Lund Humphries) 2010, p. 32.

16 Dorothea Tanning, quoted in Jean Christophe Bailly, *Dorothea Tanning*, New York (George Braziller) 1995, p. 17.

17 Frida Kahlo, quoted in 'Mexican Autobiography', *Time*, 27 April 1953, p. 90. See also Hayden Herrera, *Frida Kahlo*, New York (Rizzoli) 1992, p. 228.

18 Elizabeth Peyton, quoted in Calvin Tomkins, 'The Artist of the Portrait', *The New Yorker*, 10 May 2008, p. 42.

19 Since 2003 Peyton has increasingly been working from life, as well as from made images. She has also exhibited the photographs of her sitters as finished objects.

20 Elizabeth Peyton, quoted in Steve Lafreniere, 'A Conversation with the Artist', in Elizabeth Peyton *et al.*, *Elizabeth Peyton*, New York (Rizzoli) 2005, p. 253.

Bibliography

GENERAL ART HISTORY

Frances Borzello, *A World of Our Own: Women as Artists Since the Renaissance*, New York (Watson-Guptill) 2000

Norma Broude and Mary D. Garrard, *The Expanding Discourse: Feminism and Art History*, New York (HarperCollins) 1992

——, eds, *Reclaiming Female Agency: Feminist Art History After Postmodernism*, Berkeley, Calif. (University of California Press) 2005

Whitney Chadwick, *Women, Art, and Society*, 4th edn, London (Thames & Hudson) 2007

Alicia Foster, *Tate Women Artists*, London (Tate) 2004

Germaine Greer, *The Obstacle Race: The Fortunes of Women Painters and Their Work*, New York (Farrar, Straus and Giroux) 1979

Guerrilla Girls, *The Guerrilla Girls' Bedside Companion to the History of Western Art*, New York (Penguin) 1998

Nancy G. Heller, *Women Artists: An Illustrated History*, 3rd edn, New York (Abbeville Press) 1997

Lucy R. Lippard, *The Pink Glass Swan: Selected Essays on Feminist Art*, New York (New Press) 1995

Modern Women: Women Artists at the Museum of Modern Art, exhib. cat., ed. Cornelia H. Butler and Alexandra Schwartz, New York, The Museum of Modern Art, 2010

Cindy Nemser, *Art Talk: Conversations with 15 Women Artists*, rev. and enl. edn, New York (Icon Editions) 1995

Linda Nochlin, 'Why Have There Been No Great Women Artists?' *ARTnews*, 69, January 1971, pp. 22–29, 67–71

——, *Women, Art, and Power: And Other Essays*, New York (Harper & Row) 1988

Rozsika Parker and Griselda Pollock, *Old Mistresses: Women, Art and Ideology*, London (Routledge and Kegan Paul) 1981

Chris Petteys, *Dictionary of Women Artists: An International Dictionary of Women Artists Born Before 1900*, Boston (G.K. Hall) 1985

Griselda Pollock, *Vision and Difference: Femininity, Feminism and Histories of Art*, London (Routledge) 1988

Helena Reckitt and Peggy Phelan, *Art and Feminism*, London (Phaidon) 2001

Wendy Slatkin, *Women Artists in History: From Antiquity to the Present*, 3rd edn, Upper Saddle River, NJ (Prentice Hall) 1997

Women Artists: 1550–1950, exhib. cat. by Ann Sutherland Harris and Linda Nochlin, Los Angeles, Austin, Pittsburgh and Brooklyn, 1976–77

HISTORICAL AND REGIONAL STUDIES

Amazons of the Avant-Garde, exhib. cat. by John E. Bowlt and Matthew Drutt, Berlin, London, Venice and New York, 1999–2000

Norma Broude and Mary D. Garrard, eds, *The Power of Feminist Art: The American Movement of the 1970s, History and Impact*, New York (Harry N. Abrams) 1994

Mary Ann Caws, *Glorious Eccentrics: Modernist Women Painting and Writing*, New York (Palgrave Macmillan) 2006

Whitney Chadwick, *Women Artists and the Surrealist Movement*, Boston (Little, Brown and Company) 1985

Deborah Cherry, *Painting Women: Victorian Women Artists*, London and New York (Routledge) 1993

Julia K. Dabbs, *Life Stories of Women Artists, 1550–1800: An Anthology*, Farnham (Ashgate) 2009

Katy Deepwell, ed., *Women Artists and Modernism*, Manchester (Manchester University Press) 1998

Tamar Garb, *Sisters of the Brush: Women's Artistic Culture in Late Nineteenth-Century Paris*, New Haven, Conn., and London (Yale University Press) 1994

Global Feminisms: New Directions in Contemporary Art, exhib. cat., ed. Maura Reilly and Linda Nochlin, Brooklyn Museum, March–July 2007; Wellesley College, Mass., Davis Museum and Cultural Center, September–December 2007

Uta Grosenick, ed., *Women Artists in the 20th and 21st Century*, Cologne (Taschen) 2001

Laurie Collier Hillstrom and Kevin Hillstrom, eds, *Contemporary Women Artists*, Detroit (St James Press) 1999

Geraldine A. Johnson and Sara F. Matthews Grieco, eds, *Picturing Women in Renaissance and Baroque Italy*, Cambridge (Cambridge University Press) 1997

Power Up: Female Pop Art, exhib. cat. by Angela Stief *et al.*, Vienna, Hamburg and Bietigheim-Bissingen, 2010–11

Moira Roth, ed., *The Amazing Decade: Women and Performance Art in America, 1970–1980*, Los Angeles (Astro Artz) 1983

Charlotte Streifer Rubinstein, *American Women Artists: From Early Indian Times to the Present*, New York (Avon) 1982

WACK! Art and the Feminist Revolution, exhib. cat., ed. Lisa Gabrielle, Los Angeles, Washington, D.C., Long Island City and Vancouver, 2007–2009

Women Impressionists, exhib. cat., ed. Ingrid Pfeiffer and Max Hollein, Schirn Kunsthalle Frankfurt, February–June 2008; Fine Arts Museum of San Francisco, June–September 2008

INDIVIDUAL ARTISTS

Marina Abramovic
Marina Abramovic: The Artist is Present, exhib. cat. by Klaus Biesenbach, New York, The Museum of Modern Art, March–May 2010

Sofonisba Anguissola
Sofonisba Anguissola: Renaissance Woman, exhib. cat. by Sylvia Ferino-Pagden, Washington, D.C., National Museum of Women in the Arts, April–June 1995

Mariya Bashkirtseva
Mariya Bashkirtseva, *Marie Bashkirtseff: The Journal of a Young Artist 1860–1884*, trans. Mary J. Serrano, New York (E.P. Dutton) 1926

Vanessa Beecroft
Vanessa Beecroft: Performances 1993–2003, exhib. cat. by Marcella Beccaria, Castello di Rivoli Museo d'Arte Contemporanea, October 2003 – January 2004; Kunsthalle Bielefeld, May–August 2004

Isabel Bishop
Isabel Bishop: The Affectionate Eye, exhib. cat. by Bruce St John, Los Angeles, Laband Art Gallery, February–March 1985

Rosa Bonheur
Anna Klumpke, *Rosa Bonheur: The Artist's (Auto)biography*, trans. Gretchen van Slyke, Ann Arbor, Mich. (University of Michigan Press) 1997

Isabelle de Borchgrave
Pulp Fashion: The Art of Isabelle de Borchgrave, exhib. cat. by Jill D'Alessandro, San Francisco, Legion of Honor, February–June 2011

Louise Bourgeois
Louise Bourgeois, exhib. cat., ed. Frances Morris, London, Paris, New York, Los Angeles and Washington, D.C., 2007–2009

Julia Margaret Cameron
Julia Margaret Cameron: The Complete Photographs, exhib. cat. by Julian Cox and Colin Ford, Los Angeles, The J. Paul Getty Museum; Bradford, National Media Museum, 2003

Rosalba Carriera
Rosalba Carriera: Prima pittrice de l'Europa, exhib. cat. by Giuseppe Pavanello, Venice, Galleria di Palazzo Cini a San Vio, September–October 2007

Leonora Carrington
Susan L. Aberth, *Leonora Carrington: Surrealism, Alchemy and Art*, Farnham (Lund Humphries) 2010

Mary Cassatt
Mary Cassatt: Modern Woman, exhib. cat. by Judith A. Barter and Erica E. Hirshler, Chicago, Boston and Washington, D.C., 1998–99

Elizabeth Catlett
Elizabeth Catlett: In the Image of the People, exhib. cat. by Melanie Herzog, Art Institute of Chicago, November 2005 – February 2006

Judy Chicago
Judy Chicago, *The Dinner Party: From Creation to Preservation*, London and New York (Merrell) 2007

Camille Claudel
Camille Claudel and Rodin: Fateful Encounter, exhib. cat. by Odile Ayral-Clause *et al.*, Quebec, Detroit and Martigny, 2005–2006

Renée Cox
Shelly Eversley, 'Renee Cox: The Big Picture', *Nka: Journal of Contemporary African Art*, 18, Spring/Summer 2003, pp. 72–75

Sonia Delaunay
Color Moves: Art and Fashion by Sonia Delaunay, exhib. cat. by Matilda McQuaid *et al.*, New York, Cooper-Hewitt, National Design Museum, March–June 2011

Tracey Emin
Love is What You Want, exhib. cat. by Cliff Lauson *et al.*, London, Hayward Gallery, May–August 2011

Lavinia Fontana
Caroline P. Murphy, *Lavinia Fontana: A Painter and Her Patrons in Sixteenth-Century Bologna*, New Haven, Conn., and London (Yale University Press) 2003

Artemisia Gentileschi
Mary D. Garrard, *Artemisia Gentileschi: The Image of the Female Hero in Italian Baroque Art*, Princeton, NJ (Princeton University Press) 1989

Natal'ya Goncharova
Natalia Goncharova: Between Russian Tradition and European Modernism, exhib. cat., ed. Beate Kemfert, Opelvillen Rüsselsheim, Lubeck and Erfurt, 2009–10

Eva Gonzalès
Carol Jane Grant, 'Eva Gonzalès (1849–1883): An Examination of the Artist's Style and Subject Matter', PhD diss., Ohio State University, 1994

Guerrilla Girls
Guerrilla Girls, *Confessions of the Guerrilla Girls*, New York (HarperCollins) 1995

Candida Höfer
Candida Höfer: Projects Done, exhib. cat. by Candida Höfer *et al.*, Leverkusen, Museum Morsbroich, May–August 2009; Vienna, Belvedere, October 2010 – January 2011

Rebecca Horn
Rebecca Horn: The Glance of Infinity, exhib. cat., ed. Carl Haenlein, Hannover, Kestner Gesellschaft, May–July 1997

Rebecca Horn, exhib. cat. by Germano Celant *et al.*, New York, Eindhoven, Berlin, Vienna, London and Grenoble, 1993–95

Gwen John
Sue Roe, *Gwen John: A Painter's Life*, New York (Farrar, Straus and Giroux) 2001

Frida Kahlo
Frida Kahlo, exhib. cat., ed. Elizabeth Carpenter, Minneapolis, Philadelphia and San Francisco, 2007–2008

Angelica Kauffman
Angela Rosenthal, *Angelica Kauffman: Art and Sensibility*, New Haven, Conn., and London (Yale University Press for the Paul Mellon Centre for Studies in British Art) 2006

Käthe Kollwitz
Käthe Kollwitz, exhib. cat. by Elizabeth Prelinger, Washington, D.C., National Gallery of Art, May–August 1992

Lee Krasner
Gail Levin, *Lee Krasner: A Biography*, New York (HarperCollins) 2011

Adélaïde Labille-Guiard
Laura Auricchio, *Adélaïde Labille-Guiard: Artist in the Age of Revolution*, Los Angeles (J. Paul Getty Museum) 2009

Edmonia Lewis
Kirsten Pai Buick, *Child of the Fire: Mary Edmonia Lewis and the Problem of Art History's Black and Indian Subject*, Durham, NC (Duke University Press) 2010

Judith Leyster
Judith Leyster: A Dutch Master and Her World, exhib. cat. by J.A. Welu *et al.*, Haarlem, Frans Hals Museum, May–August 1993; Worcester Art Museum, Mass., September–December 1993

Barbara Longhi
Liana DeGirolami Cheney, 'Barbara Longhi of Ravenna', *Woman's Art Journal*, 9, Spring–Summer 1988, pp. 16–20

Maria Sibylla Merian
Maria Sibylla Merian and Daughters: Women of Art and Science, exhib. cat. by Ella Reitsma, trans. Lynne Richards, Amsterdam, Rembrandt House Museum, February–May 2008; Los Angeles, The J. Paul Getty Museum, June–August 2008

Berthe Morisot
Anne Higonnet, *Berthe Morisot's Images of Women*, Cambridge, Mass. (Harvard University Press) 1992

Alice Neel
Alice Neel: Painted Truths, exhib. cat. by Barry Walker *et al.*, Houston, London and Malmö, 2010–11

Shirin Neshat
Arthur C. Danto, *Shirin Neshat*, New York (Rizzoli) 2010

Georgia O'Keeffe
Lisa Mintz Messinger, *Georgia O'Keeffe*, London (Thames & Hudson) 2001

Catherine Opie
Catherine Opie: American Photographer, exhib. cat. by Jennifer Blessing and Nat Trotman, New York, Solomon R. Guggenheim Museum, September 2008 – January 2009

Meret Oppenheim
Meret Oppenheim: Beyond the Teacup, exhib. cat. by Jacqueline Burckhardt and Bice Curiger, New York, Solomon R. Guggenheim Museum, June–October 1996

Elizabeth Peyton
Elizabeth Peyton *et al.*, *Elizabeth Peyton*, New York (Rizzoli) 2005

Paula Rego
John McEwen, *Paula Rego*, 3rd edn, London (Phaidon) 2006

Bridget Riley
Bridget Riley Retrospective, exhib. cat. by Anne Montfort *et al.*, Musée d'Art Moderne de la Ville de Paris, June–September 2008

Marietta Robusti
Carlo Ridolfi, *The Life of Tintoretto, and of His Children Domenico and Marietta* [1648], trans. Catherine Enggass and Robert Enggass, University Park, Pa. (University of Pennsylvania Press) 1984

Jenny Saville
John Gray *et al.*, *Jenny Saville*, New York (Rizzoli) 2005

Rolinda Sharples
Kathryn Metz, 'Ellen and Rolinda Sharples: Mother and Daughter Painters', *Woman's Art Journal*, 16, Spring–Summer 1995

Amrita Sher-Gil
Amrita Sher-Gil, *A Self-Portrait in Letters and Writings*, 2 vols, ed. Vivan Sundaram, New Delhi (Tulika Books) 2010

Cindy Sherman
Cindy Sherman: Retrospective, exhib. cat. by Amanda Cruz *et al.*, Los Angeles, Museum of Contemporary Art, then touring, 1997–2000

Elizabeth Siddal
Elizabeth Siddal, 1829–1862: Pre-Raphaelite Artist, exhib. cat. by Jan Marsh, Sheffield, The Ruskin Gallery, 1991

Kiki Smith
Kiki Smith: Prints, Books and Things, exhib. cat. by Wendy Weitman, New York, The Museum of Modern Art, December 2003 – March 2004

Rebecca Solomon
Roberto C. Ferrari, 'Rebecca Solomon: Pre-Raphaelite Sister', *Review of the Pre-Raphaelite Society*, 12, Summer 2004, pp. 23–36

Marie Spartali Stillman
David B. Elliott, *A Pre-Raphaelite Marriage: The Lives and Works of Marie Spartali Stillman and William James Stillman*, Woodbridge (Antique Collectors' Club) 2006

Renée Stout
Astonishment and Power, exhib. cat. by Wyatt MacGaffey and Michael D. Harris, Washington, D.C., National Museum of African Art, April–January 1994

Dorothea Tanning
Jean Christophe Bailly, *Dorothea Tanning*, New York (George Braziller) 1995

Elizabeth Thompson
Elizabeth Butler, *An Autobiography*, Boston (Houghton Mifflin) 1923

Suzanne Valadon
Rosemary Betterton, 'How Do Women Look? The Female Nude in the Work of Suzanne Valadon', *Feminist Review*, 19, Spring 1985, pp. 3–24

Elisabeth Vigée-Lebrun
Mary D. Sheriff, *The Exceptional Woman: Elisabeth Vigée-Lebrun and the Cultural Politics of Art*, Chicago and London (University of Chicago Press) 1996

Kara Walker
Kara Walker: Slavery! Slavery!, exhib. cat. by Robert Hobbs, 25th International Biennial of São Paulo, March–June 2002

Picture Credits

© Marina Abramovic. Courtesy of Marina Abramovic and Sean Kelly Gallery, New York. DACS 2012: 117; © ADAGP, Paris and DACS, London 2012. Photo: Philadelphia Museum of Art, Pennsylvania, PA, USA/Giraudon/ The Bridgeman Art Library: 145; © ADAGP, Paris and DACS, London 2012. Photo: Tretyakov Gallery, Moscow, Russia/The Bridgeman Art Library: 93; akg-images: jacket front and spine, 29, 35, 71; akg-images/Private collection/Courtesy Noortman Master Paintings: jacket back (bottom right), 64, 69; Alinari/The Bridgeman Art Library: 106, 108; Apic/Getty Images: 50; © ARS, NY and DACS, London 2012. Photo: Albright Knox Art Gallery/Art Resource, NY/Scala, Florence: 38; © ARS, NY and DACS, London 2012. Photo: The Metropolitan Museum of Art/Art Resource/Scala, Florence: 143; The Art Archive/Musée des Arts Décoratifs, Paris: 51; Giulio Azzarello/Rex Features: 83; © 2012. Banco de México Diego Rivera Frida Kahlo Museums Trust, Mexico, D.F./ DACS. Photo: Art Resource/Bob Schalkwijk/Scala, Florence: 147; Karl Heinz Bast/Alinari Archives, Florence/ Getty Images: 112; Adam Berry/ Bloomberg News/Getty Images: 59; Bibliothèque Nationale, Paris, France/ Giraudon/The Bridgeman Art Library: 7; © Bristol City Museum and Art Gallery, UK/The Bridgeman Art Library: 138; Frederick M. Brown/ Getty Images: 115; Henry Herschel Hay Cameron/Getty Images: 48; Dario Cantatore/Retna Ltd/Corbis: 17; © Elizabeth Catlett. DACS, London/ VAGA, New York 2012. Photo: The Museum of Modern Art, New York/ Scala, Florence: 114; © Judy Chicago/ ARS, NY and DACS, London 2011. Photo: Donald Woodman: 97; © Renée Cox. Image courtesy Phillips de Pury & Company: 124–25; © DACS 2012. Photo: Hermitage, St Petersburg, Russia/The Bridgeman Art Library: 110; © DACS 2012. Photo: The Museum of Modern Art, New York/ Scala, Florence: 113; David and Alfred Smart Museum of Art, University of Chicago/The Bridgeman Art Library: 14; Delaware Art Museum, Wilmington, USA/Gift of Lucia N. Valentine/The Bridgeman Art Library: 141; Andreas von Einsiedel: 62, 63; © Tracey Emin. All rights reserved, DACS 2012. Photo: Stephen White, courtesy White Cube: 127; The Estate of Dame Laura Knight DBE RA 2012, reproduced with permission. All rights reserved: 2; Tony Evans/Getty Images: 55; Fotosearch/ Getty Images: 32; © Georgia O'Keeffe Museum/DACS, 2012. Photo: Brooklyn Museum of Art, New York, USA/ Bequest of Edith and Milton Lowenthal/

The Bridgeman Art Library: 37; Getty Images/The Bridgeman Art Library: 31; Paul Gilham/Getty Images: 126; Scott Gries/Getty Images: 125; © Guerrilla Girls/Courtesy guerrillagirls.com: 16, 121; Nick Harvey/Wire Image/Getty Images: 80; © Candida Höfer, VG Bild-Kunst, Bonn 2005/DACS 2012: 60; E.O. Hoppé/Getty Images: 111; © Rebecca Horn/DACS 2012. Photo: Tate/Tate Images: 77; Hulton Archive/ Getty Images: 74, 89; Imagno/ Franz Hubmann/Getty Images: 92; Indianapolis Museum of Art, USA/ Delavan Smith Fund/The Bridgeman Art Library/Courtesy the Estate of Isabel Bishop and DC Moore Gallery, NY: 94; Michael Kappeler/AFP/ Getty Images: 82; Jason Kempin/Getty Images: 100; John Loengard/Time Life Pictures/Getty Images: 36; © Louise Bourgeois Trust/DACS, London/ VAGA, New York 2012. Photo: Munson Williams Proctor Arts Institute/Art Resource, NY/Scala, Florence: 99; Cynthia Macadams/Time Life Pictures/ Getty Images: 96; © Jenny Matthews/ Alamy: 15; The Metropolitan Museum of Art/Art Resource/Scala, Florence: 26–27, 75, 135; Ralph Müller: 61; Musée des Beaux-Arts, Bordeaux. Photo: L. Gauthier: 10; Musée Rodin, Paris, France/Peter Willi/The Bridgeman Art Library: 34; Museum of Fine Arts, Boston, Massachusetts, USA/The Hayden Collection – Charles Henry Hayden Fund/The Bridgeman Art Library: jacket back (top right), 33; The Museum of Modern Art, New York/Scala, Florence: 72; Muzeum Narodowe, Poznan, Poland/The Bridgeman Art Library: jacket back (bottom left), 8; Muzeum Zamek, Lancut, Poland/The Bridgeman Art Library: 131; The National Gallery, London/Scala, Florence: 30; National Gallery of Victoria, Melbourne, Australia/The Bridgeman Art Library: 88–89; © National Museum Wales/ The Bridgeman Art Library: 73; National Portrait Gallery, Smithsonian Institution: 91; National Portrait Gallery, Smithsonian Institution/Art Resource/Scala, Florence: 78; © Shirin Neshat. Courtesy Gladstone Gallery, New York and Brussels: 103; © NTPL/ John Hammond/The Bridgeman Art Library: 25; © Catherine Opie. Courtesy Regen Projects, Los Angeles: 123; © Elizabeth Peyton. Courtesy of the artist, Gavin Brown's enterprise and Sadie Coles HQ, London: 149; Pierson/Getty Images: 27; Courtesy Stephanie Pina: 46; Popperfoto/Getty Images: 70; Private collection/The Stapleton Collection/The Bridgeman Art Library: 49; © Paula Rego. Image courtesy Leeds Museums and Galleries (City Art Gallery) UK/The Bridgeman

Art Library: jacket back (top left), 58; © Bridget Riley 2012. All rights reserved. Courtesy Karsten Schubert, London: 54; The Royal Collection © 2011 Her Majesty Queen Elizabeth II/The Bridgeman Art Library: 13, 45; Jun Sato/Wire Image/Getty Images: 76; © 2012 Jenny Saville. Courtesy of Gagosian Gallery/Private collection: 81; Scala, Florence: 18, 23; Scala, Florence/BPK, Bildagentur für Kunst, Kultur und Geschichte, Berlin: 21; Scala, Florence/Courtesy of the Ministero Beni e Att. Culturali: 9, 43, 67, 128, 133; Nancy R. Schiff/Hulton Archive/Getty Images: 95; Courtesy of Cindy Sherman and Metro Pictures: 56; © Kiki Smith/Universal Limited Art Editions, Inc., 2002. Photo: The Museum of Modern Art, New York/ Scala, Florence: 105; Smithsonian American Art Museum/Art Resource/ Scala, Florence: 90; Sotheby's/Private collection: 11; Renée Stout: 118; © Renée Stout. Photography courtesy the Dallas Museum of Art: 119; Courtesy Vivan and Navina Sundaram, Delhi: 40, 53; © Tate/Tate Images: 47, 84, 87; Ted Thai/Time & Life Pictures/ Getty Images: 98; Universal History Archive/Getty Images: 44; Tony Vaccaro/Hulton Archive/Getty Images: 39; M. Von Holden/FilmMagic/Getty Images: 104; © Kara Walker. Courtesy of Sikkema Jenkins & Co., New York. Photo: Dave Sweeney: 101; White Images/Scala, Florence: 137

Acknowledgements

For Paul B. Jaskot

I should like to express my gratitude to Claire Chandler and Hugh Merrell of Merrell Publishers for challenging me to explore this intriguing topic, and for their generous support throughout the project. My thanks also go to Merrell staff members Mark Ralph, for his attentive work on the typescript; Nick Wheldon, for his expert help in navigating the complex task of image selection; Tom Lobo Brennan, for producing the book's truly striking design; and Marion Moisy, for her eagle-eyed proof-reading. I am especially grateful to my outstanding research assistants, Joe Iverson, Lea Schleiffenbaum and Rebecca Schlossberg, and to my intern Vrinda Agrawal. Thanks, as well, to Rachel M. Wolff and Nika Levando for answering a few key questions. For additional research support, I should like to thank Kristan M. Hanson, Holly Stec Dankert, Jennifer A. Smith and the staff of the John M. Flaxman Library at the School of the Art Institute of Chicago. Also at the SAIC, I should like to acknowledge Lisa Wainwright, Dean of Faculty and Vice-President of Academic Affairs, and David Raskin, Chair of the Department of Art History, Theory and Criticism, in their support of my research. Finally, thanks to Donald H. Hoffman, Lindsay J. Bosch, Michal Raz-Russo and, especially, Paul B. Jaskot for all those fascinating conversations about art, women and danger.

Index

First published 2012 by Merrell Publishers, London and New York

Merrell Publishers Limited
81 Southwark Street
London SE1 0HX

merrellpublishers.com

Text, design and layout copyright © 2012 Merrell Publishers Limited
Illustrations copyright © 2012 the copyright holders; see page 156

All rights reserved. No part of this publication may be reproduced,
stored in a retrieval system or transmitted, in any form or by any
means, electronic, mechanical, photocopying, recording or otherwise,
without the prior written permission of the publisher.

British Library Cataloguing-in-Publication Data:
Mancoff, Debra N., 1950–
Danger! : women artists at work.
1. Women artists – History.
I. Title
700.8'2-dc23

ISBN 978-1-8589-4564-4

Produced by Merrell Publishers Limited
Designed by Tom Lobo Brennan
Project-managed by Mark Ralph
Indexed by Hilary Bird

Printed and bound in China

NOTE ON CAPTIONS
All dimensions indicate height followed by width followed by depth.

JACKET FRONT AND SPINE
Detail of Mariya Bashkirtseva, *In the Académie Julian*, 1881 (see page 71)

JACKET BACK, CLOCKWISE FROM TOP LEFT
Detail of Paula Rego, *The Artist in Her Studio*, 1993 (see page 58);
detail of Mary Cassatt, *In the Loge*, 1878 (see page 33); detail of Eva Gonzalès, *Le Chignon*, c. 1865–70 (see page 69); detail of Sofonisba Anguissola, *The Chess Game*, 1555 (see page 8)

PAGE 2
Laura Knight (1877–1970)
Self-Portrait with Nude
1913
Oil on canvas
152.4 × 127.6 cm (60 × 50¼ in.)
National Portrait Gallery, London

PAGE 18
Detail of Judith Leyster
Man Offering Money to a Young Woman
1631
(see page 23)

PAGE 40
Detail of Amrita Sher-Gil
Self-Portrait as a Tahitian
1934
(see page 53)

PAGE 64
Detail of Eva Gonzalès
Le Chignon
c. 1865–70
(as above)

PAGE 84
Detail of Emily Mary Osborn
Nameless and Friendless
1857
(see page 87)

PAGE 106
Detail of Artemisia Gentileschi
Judith and Her Maidservant
c. 1618–19
(see page 108)

PAGE 128
Detail of Rosalba Carriera
Self-Portrait
before 1746
(see page 133)